Peter Lanyon

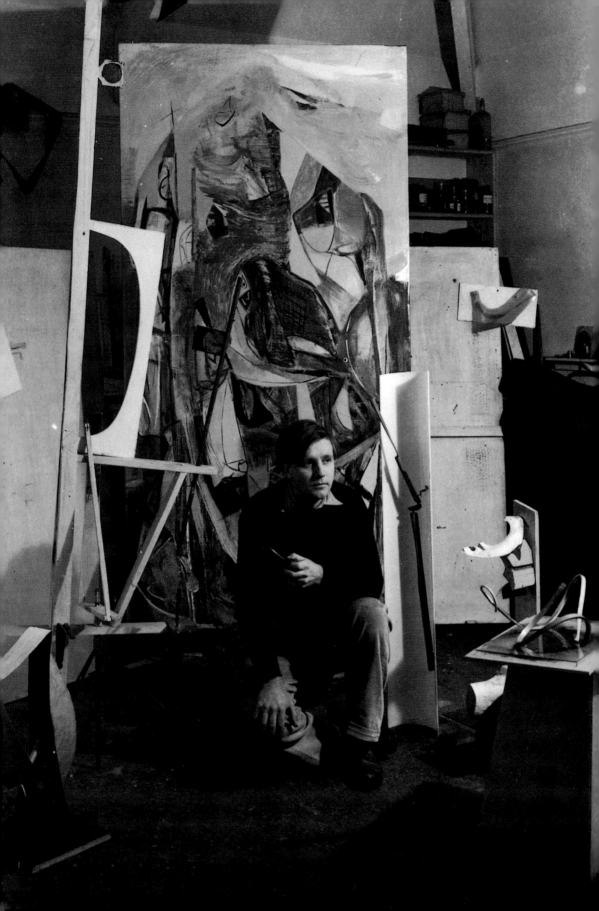

Peter Lanyon

Margaret Garlake

ST IVES ARTISTS

Tate Gallery Publishing

cover:
Clevedon Night 1964 (fig.55), detail

frontispiece:
Peter Lanyon in his studio, December 1950
Tate Gallery Archive

ISBN 1 85437 226 2

A catalogue record for this book is available
from the British Library

Published in 1998 by order of the Trustees of
the Tate Gallery by Tate Gallery Publishing Ltd,
Millbank, London SW1P 4RG

Cover designed by Slatter-Anderson, London
Book designed by Isambard Thomas

Printed in Hong Kong by South Seas
International Press Ltd

Measurements are given in centimetres, height
before width, followed by depth where
appropriate

Acknowledgements
I am, as always, most grateful to Sheila Lanyon
for giving me access to her collection, her
archive and photographs; for her patience and
her hospitality. I would also like to thank
Michael Canney, Christopher Cone, Jeremy
le Grice, Andrew Lanyon and Tony Matthews
who all been extremely helpful with information
and reminiscences; and Teresa Garlake who
read an early draft of the text.

St Ives Artists
The light, landscape and working people of
West Cornwall have made it a centre of artistic
activity for over one hundred years. This series
introduces the life and work of artists of national
and international reputation who have been
closely associated with the area and whose
work can be seen at Tate Gallery St Ives. Each
author sets out a fresh approach to our thinking
about some of the most fascinating artistic
figures of the twentieth century.

Contents

1 'A Place Man' 6

2 The Generation of Landscape 22

3 'High places and edges' 46

4 A Critical Reputation 67

Notes 76

Select Bibliography 78

Index 79

1
'A Place Man'[1]

Peter Lanyon described himself as 'a provincial landscape painter'. Of Cornish ancestry, he was born in St Ives on 8 February 1918 and lived virtually all his life in Cornwall. As a result, he is often called a Cornish or St Ives artist. Both terms are misleadingly reductive. They fail to acknowledge Lanyon's achievement as one of the most original artists of the later twentieth century. To study his work is to realise that his landscape paintings, which form the bulk of his art, have no close precedent (which is not to suggest that he did not learn from the work of other artists). They not only demonstrate a new way of representing landscape visually, but they extend our understanding of landscape itself. Although he is best known as a painter, Lanyon constantly experimented with new media, producing prints, pots, murals, stained glass, sculpture and constructions. This book, however, concentrates on the relationship between his paintings and place, since virtually all his work can be related to this central theme.

An artist's biography is not the story of his painting, though Lanyon's work was inextricably bound up with his day-to-day life. A complex man, a compound of paradoxes, he was both agonisingly sensitive and a cheerful extrovert; periodically paralysed by doubt and depression, yet an admired teacher and fluent communicator; a painstakingly professional craftsman who obsessively sought the thrills of physical danger; a talented engineer, but essentially a poet, a creator of intense and beautiful images, both visual and verbal, which we can sometimes read clearly, and at other times must grope towards blindly.

Lanyon began to paint seriously in the late 1930s. At the end of the war, still a young man, he established himself in St Ives as a professional artist. His first important group of paintings, called the 'Generation series', combines the depiction of a real place with a poetic, private mythology. Until the mid-1950s one of the dominant themes in his work was an internal, imagined, subterranean landscape, connected with the old tin-mines, whose remnants are scattered across the countryside around St Ives. Once a source of wealth that sustained entire communities and a distinctive culture, they are now ruins, identified by the gaunt silhouettes of their ventilation shafts. Lanyon's mine paintings convey his intense concern for the loss of this industry, but they are also, to a certain extent, metaphors for his own depression and the intense anxiety of a young artist struggling to find a clarity of expression.

Later, he turned to open spaces and high viewpoints and emphasised the way in which places are given their character by the weather: here a headland whipped by a north-westerly gale, there a stretch of coast drenched in sunlit blue. When he became a glider pilot in the summer of 1960 these elevated viewpoints gave way to a truly aerial vision. He painted the experience of

gliding, combining glimpses of land, sea, sky, changing weather and his own shifting sensations of turbulence, stillness and danger.

In the early 1960s Lanyon spent a considerable amount of time in the United States, stimulated by its vastness, light and brilliant colours. These qualities are apparent in his last group of paintings, made at Clevedon, near Bristol, a group to match the 'Generation series', imbued with light, colour and a new perception of place; confident, celebratory and full of a poignant sense of a future that was not to be fulfilled. He died on 31 August 1964, as the result of a gliding accident.

When Lanyon identified himself as a provincial painter, he was not referring to his remoteness from London, but to the centrality to his work of Cornwall and, especially, the area of West Penwith. Cornwall was his province, his home and the place to which he was profoundly attached. In his own words, he was 'a place man', who worked within the long tradition of English landscape painting and the intensely personal relationship between painter and geographical area: Cornwall was to Lanyon as Suffolk had been to Constable.

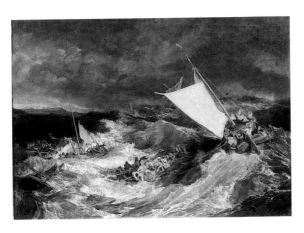

1
J.M.W. Turner
The Shipwreck
exh.1805
Oil on canvas
170.1 x 241.3 cm
Tate Gallery

Constable and Turner were Lanyon's historical heroes – revolutionary painters who, as the artist put it in a lecture given in the last year of his life, had explored 'nature as an equal, a mirror, and a source of man's desires'.[2] Constable, painting the clouds above Hampstead Heath, had revealed 'Man taking part in the play himself and not as spectator … anticipating twentieth-century journeys into space'.[3] In Turner, to whose paintings Lanyon often referred in letters to friends, he singled out 'the spiral or vortex movement with its attendant ellipses and curves'.[4] He appropriated this in his own painting, as he did the diagonal, a prominent compositional element in Turner's works like *The Shipwreck* (fig.1).

Lanyon has often been described as an abstract painter, despite his disclaimers: 'I do not consider my painting to be abstract. However, I make use of abstraction as part of my working method'.[5] He believed that the description contributed to the kind of misunderstanding that led the critic Robert Melville to write 'he seems to have mixed all his colours in preparation for atmospheric views of the Cornish scene and then slapped his paint on to the canvas in a very lively fashion without bothering to represent anything … a muffled but obsessive sense of the Cornish scene'.[6]

Yet Melville was not the only critic to be baffled by Lanyon's work, for it is not easily defined: if it is not abstract we need to ask what kind of reality it embodies and in what sense we may see it as landscape painting. Contrary to Melville's view, visual logic and other evidence suggest that every mark represents something. Lanyon's own understanding was that 'there is some reality which the artist is going to paint, but I would insist myself that the artist is usually painting a reality which has not been seen before'.[7] The basis of Lanyon's reality was always a place that he had scrutinised and come to know intimately, though his places are seldom readily recognisable. Apart from some very early work (fig.9) he never painted a straightforward view.

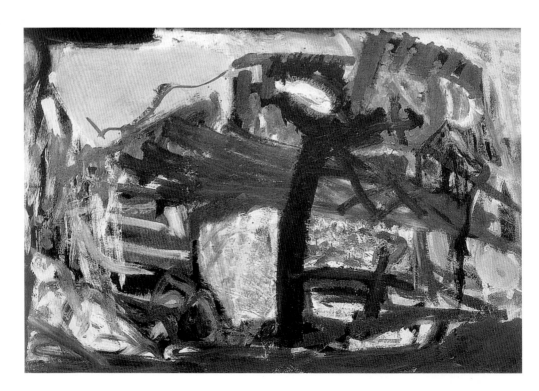

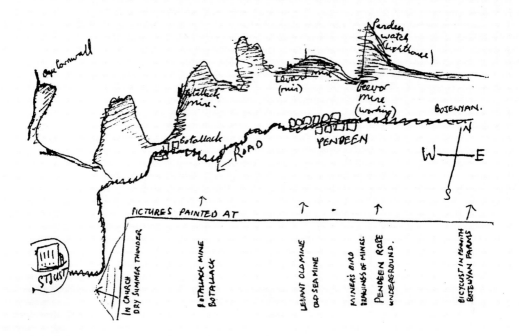

We often need Lanyon's own explanations, recorded in pithy scribbled notes, in order to decipher his paintings. Without them, while we would recognise that *Long Sea Surf* (fig.2) is a painting of a coastline, we might not realise that it is 'about a girl on a long beach near Land's End',[8] or that he connected it with the myth of Europa and the bull: 'the moment when the God disguised as a bull appears out of the sea and captures the girl'.[9] Nor is it immediately obvious, except through its title, that *Wheal Owles* (fig.3) is a painting of an extinct mine 'hacked about and plundered by miners searching for tin',[10] though we can recognise the blue of the sea, the reds and oranges that come from iron oxide, the black shaft of the mine and the rusted machinery that lies on the surface of the ground. This is not so much a painting *of* an old mine as one *about* its history, which conveys both the colours of the visible landscape and the subterranean shaft, of which we are aware but cannot see. This synthesis of the visible and the invisible is typical of Lanyon's landscape paintings, characteristically presented as a frontal view and a plan, conveyed through rich colour and sweeping brushstrokes.

To familiarise himself with places before beginning to paint them Lanyon made drawings, walked, bicycled, drove and finally flew over them. Early in his career he drew a map of the areas that he had painted in West Penwith, strung out in a linear sequence (fig.4). The map records an enterprise undertaken to gain knowledge of his province: 'I maintain the primary importance of knowing before making'.[11] Much of the information recorded in sketches, like those of the telegraph poles along the road to St Just, appears to have little connection with completed works, since a great deal was discarded as irrelevant to the final image. Though he wrote of 'an obsession to paint the image which I have in me' and of his fear of allowing 'extraneous

matter to cloud this image',[12] it is clear that for most of his career he had little idea, when beginning a painting, of how it would look in its final form. The image was, rather, a blend of intense emotion and physical sensations, which only slowly emerged in a visual form.

It was not until the 1960s that Lanyon began to embark on his canvases with a reasonably firm idea of their finished appearance. Up to this time his method had been to set down the information that emerged from his eclectic gathering process, eliminating 'extraneous matter' by prolonged over-painting, wiping out and scraping down, until there remained only the essence, transformed into coloured marks, of what made his subject unique and memorable. Difficult though it is to be precise about Lanyon's working method, we can dismiss the idea that he painted automatically like the Surrealists. He repeatedly rejected what he called fortuitous processes and, though one mark would naturally lead to another, this depended on a visual logic that required conscious decisions and numerous adjustments.

Many angles of vision, many experiences, many changes of light and weather may be recorded in a single painting. 'He tilts a landscape up and looks at it as if from the air, he extends it sideways as if seen from a car racing across it, he sounds its depths within its mineshafts' wrote John Berger, referring to *Trevalgan* (fig.5). He concluded, 'It is a painting, not of the appearance, but of the properties of a landscape'.[13] Berger's comment confirms that, to Lanyon, landscape involved much more than terrain: it embraced people, buildings, weather and history, ancient myths and modern industries, from farming to tourism. It was imbued with a sense of time – not

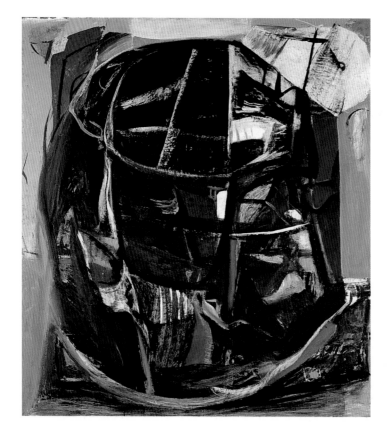

5
Trevalgan 1951
Oil on masonite
121.9 x 114.3 cm
Witte Memorial Museum,
San Antonio, Texas

only the long duration of history but seasonal cycles and the instantaneous passage of flight. Lanyon understood landscape as a constantly changing phenomenon, which is revealed through the sensations it evokes. Sound, smell and touch are no less informative than sight; a landscape is as much an imaginary place or a psychological territory as one that may be walked over.

A painting like *Trevalgan* is a synthesis of many sights and viewpoints: we see the hill with its rocky outcrops and field boundaries both in plan and full-face. Lanyon thought deeply about the consequences of abandoning conventional perspective and concluded that 'By removing the static viewpoint from landscape and introducing an image constructed or in my case *evolved* out of many experiences the problem of landscape becomes one of painting environment, place and a revelation of a time process'.[14]

The distinction between landscape and environment has been widely debated: one persuasive view is that environment may be understood as a 'function', or an active force, whereas landscape 'puts the emphasis on *form*, in just the same way that the concept of the body emphasises the form rather than the function of a living creature … body and landscape are complementary terms'.[15] Insistently, Lanyon's landscapes assume the properties of the human body. This may be recognisable through a symbol or shape, but more often the relationship between landscape and body is ambiguous, so that in a painting like *Corsham Summer* (fig.6) we see sometimes a place, sometimes a figure.

Constant overpainting and adjustment led Lanyon to create windows into space and time, like the vivid patch of blue and red that appears suddenly in the green ground of *St Just* (fig.7). He acknowledged that this conflation of time and space, which can be described as simultanism, owed a good deal to Cubist painting. More importantly though, it conveys, together with the synthesis of memory, fact and sensation that he sought to communicate, his sense of environment as a constantly evolving and changing phenomenon.

Lanyon often recorded his own presence in a painting, either as a participant in a narrative or as the activator of the image. In these cases, his actions – driving a car, flying a glider or being buffeted by a gale – are replicated in the paint, so that we recognise a streak of scarlet, like the one in *Soaring Flight* (fig.43), as the track of a glider, while its passage through space corresponds to the time necessary to make the mark. Lanyon's descriptions of his sense of physical immersion in space and landscape are keys to understanding the significance of simultanism in his work. If a painting, he explained, 'extended at a terrific rate up one side it is simply because I feel like that in my own side, in fact, I'm painting what's happened like my knee right up to my armpit … I have to project myself as it were with my feet where I am, and my head may be 50 miles away'.[16]

The Lanyons were a well-to-do, middle-class family. Peter Lanyon's parents, Lilian and Herbert, came from the tin-mining area around Redruth, where Herbert's father was a mine director. The couple moved west to St Ives on their marriage, opting for a more liberal, intellectually centred life. Herbert was a photographer, also described by a friend as 'a brilliant pianist … Sunday evenings at Lanyon's were a regular institution. He also composed'.[17] In the little town, already well known as an artists' centre, Lanyon and his sister Mary, who was only eleven months younger, grew up in the company of painters and

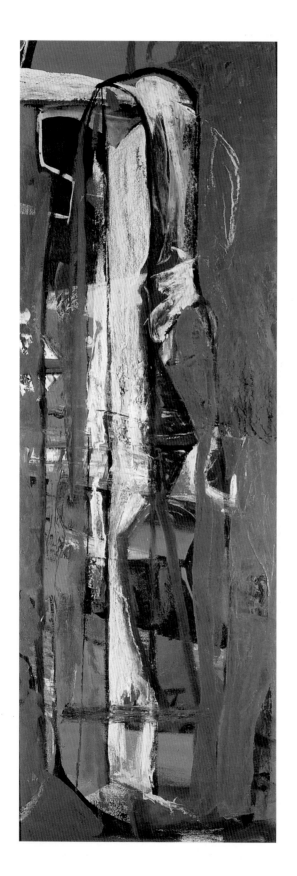

6
Corsham Summer
1952
Oil on masonite
182.8 x 60.96 cm
Private Collection

7
St Just 1952–3
Oil on canvas
243.8 x 121.9 cm
Private Collection

musicians. Herbert had a deep distaste for divisions of wealth and class, strong socialist principles that he imparted to his son along with his understanding of the centrality of the arts to a civilised life. At primary school the young Lanyon made friends with a boy called Patrick Heron. The two children formed a club, which met under a convenient hedge, where they exchanged works of art. Lanyon was designated a sculptor and Heron a painter. When, a few years later, Lanyon moved on to Clifton College, Herbert encouraged him to concentrate on music and painting in defiance of the school's conventional military and sporting ethos.

After leaving Clifton, Lanyon spent eighteen months at Penzance School of Art, intending to become a commercial artist. Although surviving paintings suggest that landscape was already his real interest, he dutifully made poster designs until, after meeting the critic and painter Adrian Stokes in 1937 and reading his book, *Colour and Form*, he recorded a 'Decision to give up Posters'. Many days were spent sketching with his sister, especially at Bosigran, a wild cape where the waves beat constantly on the dark rocks, sending up sheets of spray.

Lanyon also took private lessons from Borlase Smart, a prominent figure among artists in Cornwall and an accomplished academic painter. Smart alerted his pupil to the endurance and density of landscape, to its particular character and presence, while Lanyon in turn adopted Smart's lavish, thick paint, to form rocks and foam with solid vertical blocks of colour and with light, intersecting flicks of a laden brush. In a self-portrait, painted when he was twenty, in bright Matisse-like colours, the head was painstakingly built up, mark by mark, to become almost three-dimensional. The claim to be a sculptor made by the ten-year-old suddenly became less preposterous.

In March 1938 Lanyon, his mother and his sister travelled to South Africa, where the family had connections with the mining industry and relatives in Johannesburg. After two months in South Africa, they set off on a tour of Rhodesia (today's Zimbabwe and Zambia). Although this was not his first trip abroad – he had visited the Netherlands the previous year – Lanyon had seen nothing to prepare him for southern Africa. The dusty heat, blinding light, immense spaces and dry earth colours that can be seen in the paintings he made there, were poles apart from the soft, muted dampness of northern

8
Self-Portrait 1938
Oil on board
40.6 x 30.5 cm
Private Collection

9
Untitled
Oil on board
33 x 40.6 cm
Private Collection

Europe. Socially, southern Africa provided unwelcome insights. Johannesburg was a small town with few cultural amenities, dominated by the Rand mines. Lanyon was shocked by the racial attitudes and exploitation enacted by the white minority and distressed by the difficulty of communicating with Africans.

Nevertheless, southern Africa provided the first great formative experience of his adulthood. His obsessive painting in the rough, dry scrub, a dramatic trip, on horses, to Mont-aux-Sources, ten thousand feet up in the Drakensberg mountains, and an expedition to the magnificent ruins of Great Zimbabwe, surely contributed to his later perceptions of landscape. In Africa he saw a landscape formed, like Cornwall, by the people who lived and worked in it: African peasant farmers had their counterparts in the miners, fishermen and farmers of West Penwith.

Painting constantly, Lanyon amassed enough work for his first one-person exhibition, which was held in a small gallery in Johannesburg. Unfortunately, no records of the exhibition have been traced, though it seems likely that it opened in mid-June, just before Lanyon and his family left for home. If we compare the few identifiable African paintings with those made in Cornwall, we recognise both the impact of African colour and immensity of scale, and Lanyon's early sensitivity to the nuances of weather and topography. The early Cornish paintings often had a bluish tonality, echoing the reflections of the sea and a sky alive with great masses of cloud. In Africa, confronted with a landscape flattened by brilliant sunlight into planes of yellow, brown and grey, he transposed it as exactly as he could, producing paintings with the immediacy of snapshots, while the Cornish paintings seem to have grown out of the pigment through time.

In his abbreviated record of these years, Lanyon noted after the African journey: 'Slack Period'. The months following his return to St Ives were a difficult time since he had no clear sense of how he might best develop his work. Equally disturbing, no doubt, was the realisation that travelling to new places clearly benefited his work, raising the question of whether he should spend more time away from Cornwall. A temporary resolution came with the decision to spend two months at the Euston Road School in London during the summer of 1939, a move suggested by Adrian Stokes, who had studied there two years earlier. The Euston Road painters, as exemplified by his teachers William Coldstream and Victor Pasmore, were devoted to the exact transcription of the seen object. Much later, Lanyon recalled the forceful, though very different messages that he received from these artists: Coldstream impressed on him the need to make a meticulous record of the physical structure of the subject, while Pasmore demonstrated the use of oil-paint as a sensuous and evocative medium.

When Lanyon returned to Cornwall in the late summer of 1939, he still had no clear sense of direction. Impetuous and intellectually questing, attuned to the political and aesthetic issues of a wider world, he found Cornwall restrictive. This was the time of the Spanish Civil War – for which he briefly considered volunteering – and of the false lull that followed the Munich Agreement of September 1938. As Lanyon put it, to return to 'painting a bit of Hannibal's Carn or Zennor Carn was very boring because I had tricks and ways of doing it'.[18] He was unable to express his sense of political outrage either through direct action or in paint, since he was not yet sufficiently developed as an artist. Acutely aware that his paintings were still formulaic, he suffered what he later described as 'a sort of nervous breakdown',[19] when, not

for the last time, psychological crisis and artistic crisis were inseparable. This intensely painful episode was, however, an unavoidable prelude to a fresh set of discoveries.

The solution, once again initiated by Stokes, was to change Lanyon's entire approach to making art. Stokes and his wife, the painter Margaret Mellis, had come to live in Little Park Owles, a large, rambling property in St Ives. They had looked for a house far away from London (which was widely expected to be annihilated by bombing immediately war was declared); having found one, they invited Ben Nicholson, Barbara Hepworth and their children to join them. Only a few weeks later, Stokes and Nicholson persuaded Naum Gabo and his wife also to move to St Ives. In this way, some of the key figures of the pre-war London avant garde found themselves regrouped in Cornwall, where they rapidly became teachers and friends of the younger artists.

Gabo was their intellectual mentor. As a leading figure in the Soviet avant garde in the early 1920s, he had aligned modern art with revolutionary society, proposing it as a model for aspiration and achievement. His introduction to *Circle, International Survey of Constructive Art*, the manifesto of the Modern Movement published in 1937 and edited by Nicholson, J.L. Martin and Gabo himself, reiterated his unshakeable faith in art as a symbol of justice and harmony. His status and experience, together with his austerely beautiful constructions, afforded him a long-standing authority among artists in Cornwall, especially Lanyon, for whom he became an aesthetic father figure.

Following Stokes's suggestion, Lanyon spent a few months studying with Ben Nicholson. Reduced to a state of acute anxiety, unable to do anything but gaze at 'the plain white surface of [the] boards'[20] on which he habitually painted, he experienced a deep sense of release when he saw one of

10
Untitled 1939
Pencil and graphite on paper
24.1 x 30.4 cm
Private Collection

11
Box Construction No.1
1939–40
Wood, glass and gelatine filters
38 x 47 x 7.5 cm
The Pier Gallery, Stromness

12 *Far right*
White Track 1939–40
Mahogony, jarrah, three-ply, other wood elements, string and card
45.7 x 48.3 cm
Private Collection

Nicholson's white reliefs. Here was another artist who had resolved the dilemma of the blank surface. Some years later he explained what Nicholson had taught him. A simple group of objects would be set up, with the instruction to 'see what we can do with them; make them into not like they are but something else; let's draw lines round them, draw lines out from them and so on'.[21]

The drawing was to be constructed as a still life in space, the space taking priority over colour, shape or the logic of the eye. An untitled abstract drawing of this time shows Lanyon groping towards Nicholson's cubist arrangements of objects. On the right-hand side of the sheet a table is depicted; on the left, an abstract, coloured version is contained within a roughly drawn circle, suggesting a dialectic between a drawing made from the imagination and one showing real objects. This work introduced a theme that would recur many times in the future when, pairing opposites, Lanyon combined real and imaginary places, male and female, history and myth.

At Penzance School of Art, Lanyon had been obliged to draw antique casts, which he did unhappily. Working with Nicholson forced him to observe the structure of objects in a more analytic way. Gabo's Perspex constructions, which he admired immoderately, took the study of space into a philosophic dimension. Gabo 'was trying', Lanyon wrote, 'to define space … and he was using space like sculptors use stone'.[22]

Lanyon drew together the strands of this brief but intense encounter with constructive art in *Box Construction No.1* and *White Track* (figs.11, 12). They form a pair: the first, made of transparent sheets of gelatine, is a static

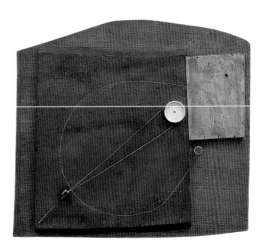

exercise in demarcating space. The second, made of several different woods, with a taut diagonal of string, which is bounded by a thin, commanding line that recalls the incisions in Nicholson's earliest reliefs, is a reflection 'on movement in painting'.[23] It has been suggested that Lanyon's deliberately limited, programmatic approach in making these first constructions reveals a scientific spirit of enquiry, deeply embedded in his thinking and complemented by a strain of poetic fantasy that delighted in myth.

On 8 March 1940 Lanyon joined the RAF and was sent to a training camp near Morecambe Bay. He wrote long, graphic letters describing the vicissitudes of service life, where marching 'About eight miles a day'[24] was fairly enjoyable, whereas the cultural and intellectual limitations of his fellow airmen were a constant trial. His greatest regret was being rejected for pilot training because he suffered from migraine. Instead, he passed the war as a flight mechanic, a job that honed his practical engineering skills and demanded constant improvisation. Some years later he wrote of a friend and fellow painter: 'he can take a poem to pieces and rebuild it, while I can take an engine to pieces and rebuild that – both should be applicable to life'.[25]

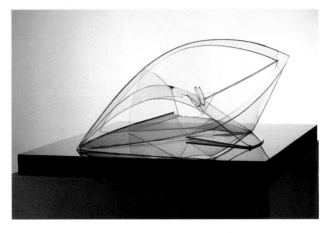

13
Naum Gabo
Spiral Theme 1941
Cellulose acetate and perspex
14 x 24.4 x 24.4 cm
Tate Gallery

14
Drawing in Oval: Agir, Palestine 1943
Pencil on paper
17.8 x 15.2 cm
Private Collection

The wartime workbench offered a rich supply of anonymous scraps of metal, glass, string and wire, all apt for transformation, as did the artist's home twenty years later. In December 1940, with little official work, Lanyon was deeply involved with a fresh set of constructions: heavy, somewhat unstable relatives of Gabo's elegant pieces, made of the detritus of aircraft engines. Although they were all destroyed, they are recorded in photographs and the detailed descriptions, with sketches, that he gave in letters to Nicholson and Hepworth. The engineer delighted in the affinities between art and the precision of machinery: 'Bright polished steel, anti corrosive treated white matt steel, black painted blades standing like a Brancusi'.[26]

Isolated though he was on his base, he kept up with events in an attenuated art world, reading the magazine *Horizon* and ordering a new book by Herbert Read, probably *Annals of Innocence and Experience* (1940). Later, he expressed his admiration for the correspondence between Gabo and Read published in *Horizon* in July 1944. It is easy to understand Lanyon's sympathy for Read. Not only was Read the leading critic of the day, who wrote with authority on artists' relationships with education, industry and politics, infused with his anarchist philosophy, but he also understood art as a multifaceted activity, a way of life as much as the production of objects, an undertaking with moral and political as well as aesthetic consequences. Above all, Read was an ally and mouthpiece for constructive artists, especially Gabo.

In May 1942, Gabo showed his *Construction in Space: Spiral Theme* (now known simply as *Spiral Theme*: fig.13) in an important exhibition, *New Movements in Art* at the London Museum. Read praised it extravagantly in *Horizon* as 'the highest point ever reached by the aesthetic intuition of man'.

Gabo had, Read felt, achieved 'the full stature of the humanist',[27] whose exemplary work had the capacity to modify people's actions. In his own constructions and paintings Lanyon was groping towards the certainty of Gabo's vision. Though he was later to diverge far from Gabo's constructive art, it provided an aesthetic and moral ideal throughout his life. Two of Lanyon's own constructions, with drawings, were also included in *New Movements in Art*, alongside work by his close friend and contemporary, John Wells. Read gave them a brief, encouraging mention in his *Horizon* article, Lanyon's first traced review.

Early in February 1942, on the point of embarkation from Blackpool to North Africa, Lanyon wrote to Hepworth and Nicholson questioning the implications of the constructive artists' claim to make art that was complete in itself: did this require the cultivation of 'an attitude which is "cut off"'? There was no quick answer. By May he was in the Western Desert, where he reported on an unexpectedly congenial life. There was plenty of opportunity to pursue his own work and a lively interest among his colleagues in 'politics, ethics, philosophy and the arts'.[28] Quite soon, perhaps shortly after the first battle of El Alamein, in July 1942, a leave in Tel Aviv gave him the opportunity to see 'the work of Marc, Marc Chagall, the Italian Futurists, Bauhaus design, Lissitzky, Feininger and many others who have been in the revolution. Also I met the Jews and that I shall never regret.'[29] He also painted small, richly toned watercolours that vividly convey the contrast between the aridity of the landscape and its occasional lush vegetation. These were interspersed with intricate abstract paintings and drawings of entwined forms within an enclosing frame. *Drawing in Oval: Agir, Palestine* (fig.14) is one of the most resolved, recalling Lanyon's

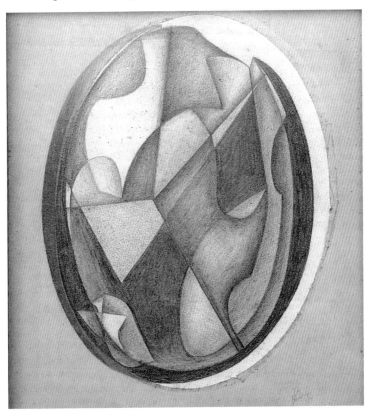

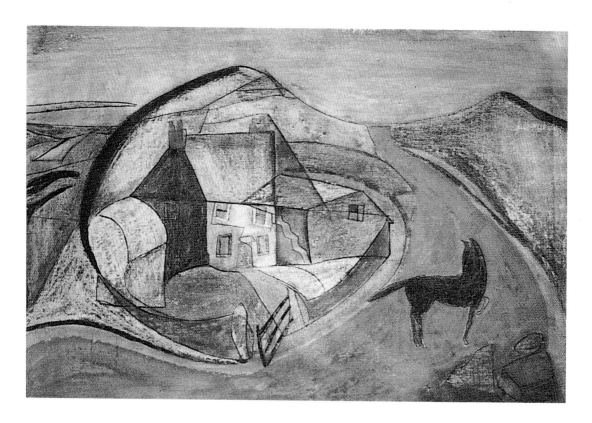

15
Blue Horse Truant
1945
Ink, crayon and
gouache on paper
38.1 x 53.3 cm
Private Collection

allegiance to Gabo, of whom he carried a constant reminder in the form of a photograph of the *Construction in Space: Spiral Theme*. Despite the revelations of Tel Aviv, the period in Palestine proved frustrating; lacking the congenial company of the Western Desert, his only sense of achievement lay in being invited, with a colleague, to design a test-rig for aircraft engines. A photograph shows him standing beside an apparatus that bears a remarkable resemblance to one of his own constructions.

On 16 February 1944, exactly two years after leaving England, he was transferred to Italy, where he spent the rest of the war. The unit disembarked at Taranto and was stationed, until the end of the year, across the narrow peninsular near Brindisi. Since the war was effectively over in Italy, he had plenty of opportunity to paint and explore the countryside. He was no longer isolated, for he soon found his way to an allied servicemen's arts club started by the writer Richard Hoggart and some friends in Naples. Hoggart recalls that Lanyon was persuaded to paint a mural, long since destroyed, which filled a whole wall: 'a great, swirling colourful thing which we all admired'.[30]

Late in 1944 he made another mural, in the officers' mess at Brindisi and described it minutely in a letter to Gabo. Set out in aircraft paint across a wall with a semi-circular top, its theme was 'wine, women and song'. Wine-barrels, bottles and a very large glass are prominent in the foreground, beside a chessboard. Two men sit behind the bar: one reads a newspaper, the other plays an accordion. In the background are a window, furniture and an immense dartboard. Although the mural had no great aesthetic merits, Lanyon clearly found it a fascinating exercise in spatial organisation on a scale far larger than anything he had previously undertaken.

During this strange tail-end of the war, a former commercial artist, Arthur Wilson, who was stationed with an RAF unit in Foggia as a photographer, started a squadron sketch club. It had its own premises in the town where Lanyon became a frequent visitor. He briefly became an enthusiastic photographer, announcing 'I am now a Camera Fiend',[31] but though he produced a little album of photographs, which includes a view of the square in Lecce, and continued to use photographs as occasional painting aids, his initial fascination soon passed. More importantly, he was beginning to reconsider his constructions, to see them as experiments and to feel a pull towards a more representational kind of art.

The Italian work of 1944–5 included Gabo-like abstracts, portraits and figure paintings, occasional still lifes and many landscapes. This was a transitional and fruitful time, for though Lanyon's situation was far from satisfactory and, like all servicemen, his one desire was to return home, he was not yet obliged to consider painting as a profession in which he had to prove himself. He was able to develop ideas without any pressure to consider where they might lead. His description of *Blue Horse Truant* (fig.15) vividly conveys the complexity of his imagery at this early date and indicates that he drew on memory and imagination no less than drawings or photographs for visual material: 'in it is Rome and the pillars I have seen and Italy in a queer gate and Godolphin [his sister's house] is the atmosphere.'[32]

By April 1945 he was in Rome, where he saw the sights and hoped to be able to show some of his work, but this seems to have proved fruitless. In December he returned to St Ives.

2
The Generation
of Landscape

Between 1945 and 1949 Lanyon produced his first coherent body of work as a professional painter. The group of paintings that he was to describe as the 'Generation series' developed from those that he had made in Italy at the end of the war, such as *Abstract Study, Italy* (fig.16)and *Blue Horse Truant* (fig.15). During this time he was deeply involved with artist-led exhibitions in St Ives and became one of the founder members of the Penwith Society, which, during the next decade, was to become one of the most important regional exhibiting societies. In April 1946 he married Sheila St John Browne. Andrew, the first of their six children, was born in May 1947, a few months before the 'Generation series' was exhibited for the first time.

The Yellow Runner (fig.17) is the best known of this group of paintings. It is also the one that he has explained most fully, as a blend of autobiography, myth and imagination, in his own words, a 'painting of a story. Runner with message on way to stockaded horses. Fox as field. Reference to horses cut in hillside. Yellow Runner as fertilising agent. Stockade as womb. A homecoming'.' The fox runs across a hillside that has been identified as the one above Gunwalloe. We also see a section through the landscape as if it were opened out to reveal an interior 'stockade' inhabited by horses. This had already appeared in a less resolved form in *Blue Horse Truant*, which, as we have seen, carried resonances of his sister's home in Cornwall. The horses are metaphors for family, wife and children yet to be born, as well as for the fertility of the land itself and, perhaps, the artist's creativity. By portraying himself as the 'runner' within this landscape, which is at least partially real, Lanyon reaffirmed his attachment to Cornwall. As well as being his subject, it was his 'stockade', a refuge in which to develop.

The Yellow Runner also reveals Lanyon's perception of himself as a modern artist. The simultaneous representation of widely scattered events and places, together with the form of the painting, where shapes are folded into one another to expose both their surface and core, as they are in Gabo's paintings, proclaim a conscious modernity and a rejection of narrative and academic art. Lanyon would continue to evolve variations on the internal/external landscape long after his work had ceased to resemble Gabo's. It was a theme that Henry Moore and Barbara Hepworth had already explored in sculpture, though it was only in 1951 that Moore made the maquettes for *Internal and External Forms* (fig.18), which is so close, in its meditative, nurturing mood, to another of Lanyon's 1947 paintings, *Generation* (fig.19).

16 *Above right*
Abstract Study, Italy
1945
Ink and gouache on paper
20.32 x 40.6 cm
Private Collection

17 *Right*
The Yellow Runner
1946
Oil on board
45.7 x 61 cm
Whereabouts unknown

18 *Left*
Henry Moore
Internal and External Forms 1953–4
Elmwood
261.6 x91.4 x 276.8 (circumference) cm

Albright-Knox Gallery, Buffalo, New York. Charles Clifton, James G. Forsyth, Edmund Hayes, and Sherman S. Jewett Funds 1955

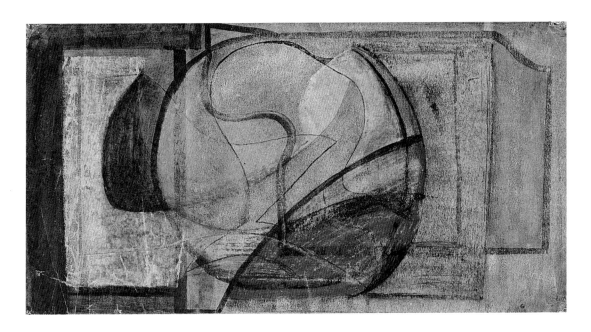

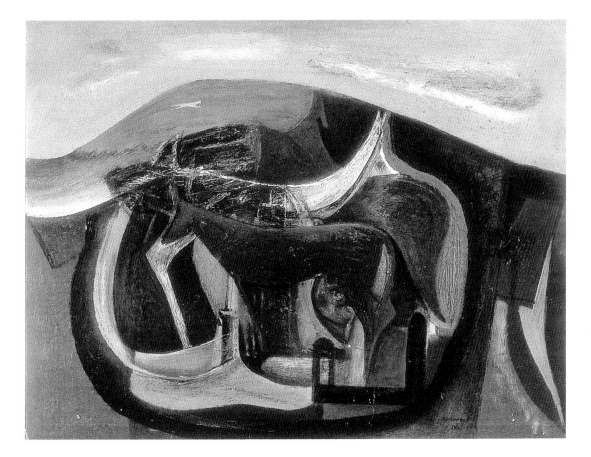

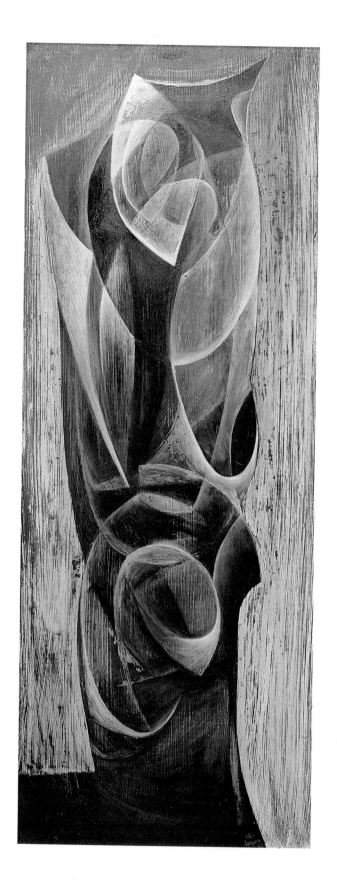

19
Generation 1947
Oil on plywood
86.4 x 33 cm
Private Collection

20
*Landscape with Cup
(Annunciation)* 1946
Oil on board
31.7 x 39.4 cm
Private Collection

While *The Yellow Runner* reflects the atmosphere of the early post-war years in suggesting the need for security, it also implies a process of metamorphosis, or interchange between categories: body and earth or animal and human. This was a central theme for artists as diverse as Francis Bacon and John Minton: it powerfully conveyed their responses to war and the existential fears that beset the post-war world, concerning the solitude and impotence of the individual. That Lanyon addressed these contemporary ideas, however obliquely, so early in his career, indicates his awareness of artists far beyond Cornwall and his desire to situate his work at the forefront of contemporary art.

Lanyon first used the phrase the 'Generation series' in August 1947 in the catalogue for his exhibition at Downing's Bookshop in St Ives. At this point, the series consisted of four works: *The Yellow Runner*, *Generation*, *Landscape with Cup (Annunciation)* and *Prelude* (figs.17, 19, 20, 23) all of which were exhibited on this occasion. However, in February 1949, Lanyon wrote to Gabo that this series 'took about 18 months to complete and consisted of eight works'.[2] He never named the four additional paintings. Their identity remains a mystery for which art historians have offered various solutions.

The title 'Generation series' suggests that the linking thread is fertility, creativity and birth. The series was stimulated by the bright, optimistic,

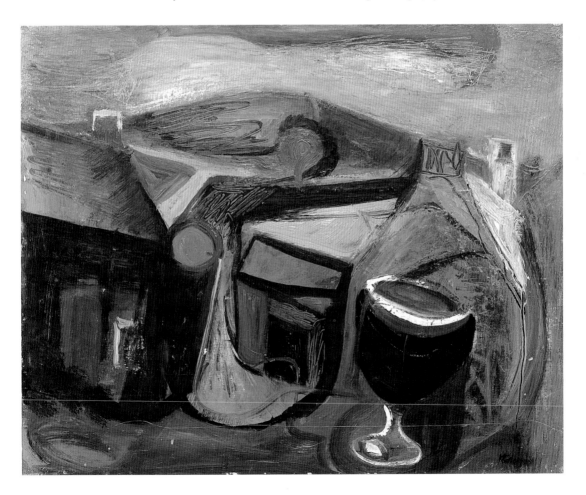

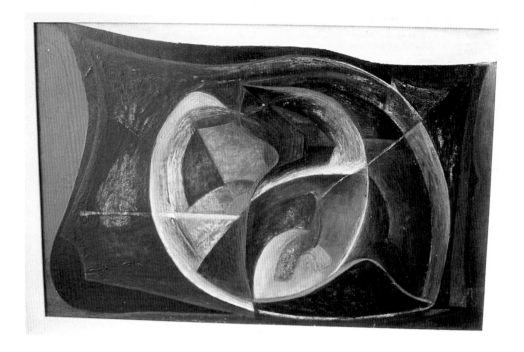

dynamic *Generator* (fig.21), while Lanyon also emphasised that *Generation*, calm and softly coloured, completed the series: 'The final picture of the series being vertical has a curious relationship to a mother and child.'[3] We may thus understand *Generator* and *Generation* as a pair that frames the series. The paintings that lay between them chronologically, including those whose identifications remain speculative, may be read as episodes between initiation and fulfilment. They all develop the idea of real events in the external world that are echoed in a deep internal space located both within the earth and in the mind. They also fall into pairs, of which one half is concerned with the visible world and the other with the inner realm of the imagination. Thus, one part of each pair is markedly more abstract than the other. Lanyon's comment, on finishing the series, was that it 'appears to be inner. They all derive information from the tin mines here and other things under the soil.'[4] We see 'other things under the soil' in *The Yellow Runner*, for which we have Lanyon's annotation to remind us that the runner and the stockade with horses were metaphors for a story in which he was passionately emotionally involved.

The Yellow Runner may perhaps be paired with *Earth* (fig.22), which appears to have developed from *Abstract Study, Italy*. There is an even clearer relationship between *Landscape with Cup* and *Prelude*. Real objects in the first correspond to more abstract shapes in the second. The central area, which in *Landscape with Cup* shows a structure against a corn-yellow ground, translates in *Prelude* into an enclosed space within sheltering curves. Similarly, the cup becomes a fluid curve in *Prelude* and the building on the left a subdivided egg-like shape. No fully satisfactory identifications have been proposed for the remaining two paintings, though the art historian Andrew Causey has suggested *Construction in Green* (1947; private collection), which

21 *Right*
Generator 1946
Oil on canvas
76.2 x 50.8 cm
Private Collection

22 *Above*
Earth 1946
Oil on board
41.9 x 63.5 cm
Private Collection

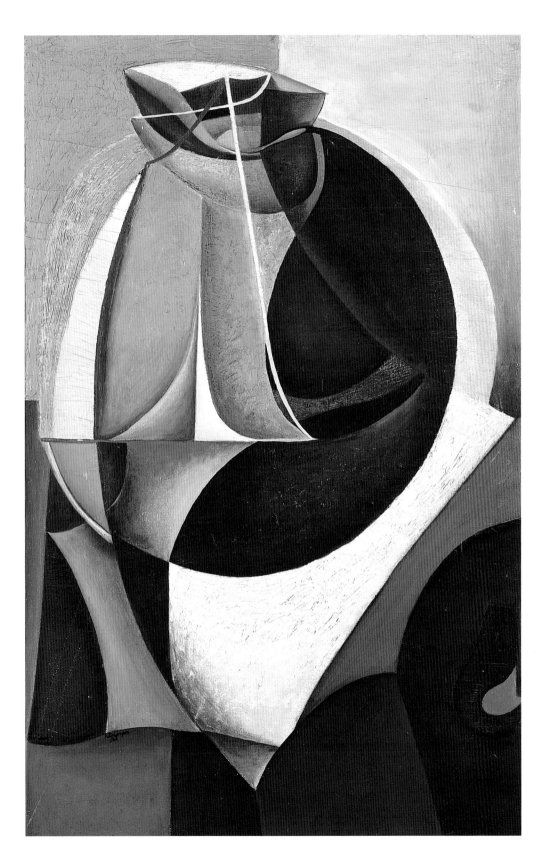

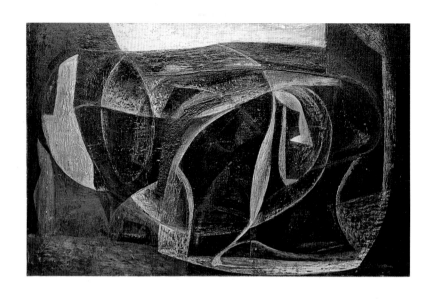

23
Prelude 1947
Oil on canvas
61 x 96.5 cm
Private Collection

24
Tinstone 1947
Wax resist, crayon and
wax on board
33 x 40.6 cm
Private Collection

25 *Right*
First Crypt Group
exhibition, September
1946
Photo: Tate Gallery Archive

is convincing because of its similarity to Gabo's paintings and sculpture. A plausible fellow to it is the wax-resist drawing, *Tinstone* (fig.24). Its tracery of fine lines against the blood-red of mineral-rich soil suggests a parallel between the working of the land and the artist's quarrying of themes and motifs.

After more than five years in the RAF, Lanyon, like other men and women returning from the war, had a compulsive need to re-establish his life and career. Many young artists, aware that they were contributing to the formation of a new society, shared Victor Pasmore's belief that 'Today the whole world is shaken by the spirit of reconstruction … In painting and sculpture, as also in architecture, an entirely new language has been formed'.[5] For Lanyon and others, constructive art remained an ideal but, if only because it was identified with an earlier avant garde, it was no longer an entirely satisfactory model. A younger generation recognised the need to develop an art more attuned to the uncertainties of the post-war world.

When Lanyon returned to St Ives in 1945, the balance of the artists' community was soon to change radically. Stokes had already left, while Gabo and his family were to emigrate to the United States the following November: the younger artists were about to be thrown back on their own resources. Their immediate response was to form an exhibiting group. Lanyon, Wells, Sven Berlin, Bryan Wynter and the printer, Guido Morris held their first joint exhibition in September 1946. They called themselves the Crypt Group, since the show took place in the crypt of the Mariners' Church in St Ives (fig.25). As an assertion of identity it was undoubtedly successful: the exhibition stimulated a lively correspondence in the local press.

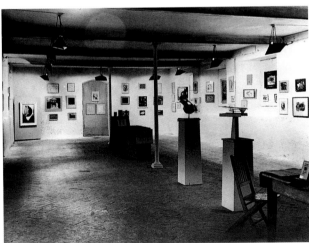

Among Lanyon's twenty-six works were ten paintings made during the war, one of which was *Blue Horse Truant*. Their second exhibition, in which he first showed the four identified paintings from the 'Generation series', was held in August 1947. Nine artists took part in the third and final Crypt show in August 1948, when a commercially produced catalogue replaced Morris's beautiful handprinted documents. Short-lived though the Group was, it was extremely significant, especially for Lanyon and Wells who, within two years, had established a credible alternative to the constructive art that had dominated St Ives since 1939. After having made a series of relief constructions during the war when he had practised as a medical doctor in the Scilly Isles, Wells turned to painting. These works were often based on a Golden Section format and have the appearance of abstracts though they developed from the familiar sights of the sea, shells, rocks and birds.

By September 1948 the Crypt artists had ensured that St Ives, no longer the outpost of a refugee avant garde, would in future be associated with a wide range of advanced art and, particularly, with so-called abstract landscape

29

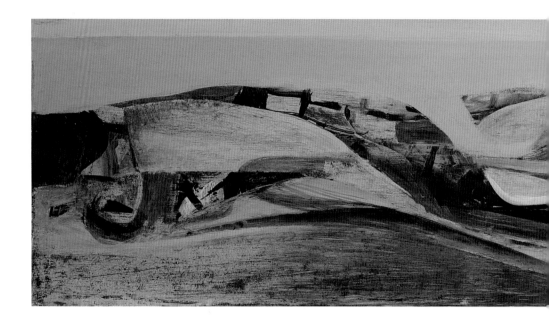

26
West Penwith 1949
Oil on plywood
29.2 x 109.2 cm
Private Collection

painting. St Ives had begun to assume a new identity as an art centre, in which Lanyon, always an active participant rather than an onlooker, was a prime mover. Apart from the more reclusive John Wells, he was the only Cornish-born artist among the young modernists. This, he felt, gave him a special position in comparison with those who, like Guido Morris and Bryan Wynter, had only arrived after the war. Patrick Heron had spent the first ten years of his childhood in Cornwall and, until he moved back there permanently in 1956, visited regularly during the summers. In the early post-war years, when Heron was art critic first for *The New English Weekly*, then *The New Statesman and Nation*, he supported his colleagues in St Ives by bringing their work to the notice of a wider public. By the time of the third Crypt show, Wynter, Berlin and Wells had already held individual exhibitions in London's West End galleries. Heron's perceptive encouragement was no doubt much appreciated for, despite their achievement in breaking into the wider context of London critics and dealers, to older modernists and more conventional artists in St Ives it seemed that the Crypt Group generation had rejected their mentors and the established hierarchy.

Despite the impact of these initiatives, the years immediately after the war were extremely difficult for Lanyon. Under a growing compulsion to paint landscape, he was disturbed by the thought that Gabo might see this as a betrayal. The problem was to find a personal idiom in which he could hold fast to the ethical idealism of Gabo's constructive principle. In this context, we may see *Construction* (fig.27), the last of the abstract constructions that Lanyon ironically described as 'Gaboids', as a valedictory work. He sensed 'opposition from every quarter of my own age and generation'[6] and consequently felt isolated from other artists in St Ives, always excepting John Wells, whose path away from constructive art paralleled his own. He was also acutely aware of

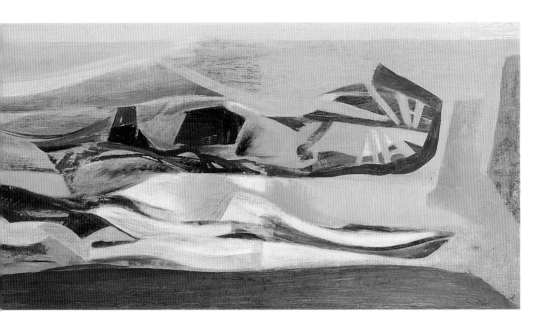

the general polarisation between advanced and traditional artists throughout the country, manifested as a 'pernicious reaction to anything that seems to suggest Abstraction or Construction'.[7] Progressive artists, wherever they worked, had great difficulty in persuading galleries to accept their art and even more intractable problems in selling it.

The Crypt Group had provided a cushion against this isolation, which many of the artists still vividly remember. It could not, however, stave off the terrible depression that Lanyon suffered under the stress of reformulating his work. He described the effort of painting the 'Generation series' as 'very much like climbing the ventilation shaft of a mine inch by inch away from a tomb',[8] an image of despair made more graphic by the fact that he suffered from claustrophobia. A year later, in May 1948, he was still tormented by the effort of painting, which had driven him to physical collapse.

By February 1949, when he wrote a long letter to Gabo outlining the themes of the 'Generation series', he felt himself cured. Tantalisingly, he also described a second, but unidentified, series which culminated with the painting *West Penwith* (fig.26). Though linked to the 'Generation series', it was distinguished by having 'left the inner forms of the mines and of seeds and begun to evolve a relationship of these forms to the outer forms of the surface'.[9] *West Penwith*, which refers to the area around St Ives that signified home, is an important though little exhibited work. Its extreme horizontality, which underwrites the message of the painted image, is its most striking feature. Composed on two long, interwoven curves, in the hazy blues and greens characteristic of the area, it is a translation of colour and topography into Lanyon's most sophisticated and accomplished synthesis to date of multiple viewpoints. A few months after finishing *West Penwith* he wrote a short article called 'The Face of Penwith', a verbal portrait of the landscape and its history. It confirms

that writing was already important to him as a way of clarifying ideas. He described the countryside as being like one of his own paintings and the process of writing as a parallel to painting, undertaken 'in the hope that processes of revelation, extension and creation … may themselves be revealed and shown to have a relativity in time and space'.[10]

West Penwith was first shown in the inaugural exhibition of the Penwith Society in June 1949, together with *Portreath* (fig.28), which he described as a 'direct portrait of a place'.[11] Some years later he explained to the architect Eugene Rosenberg, the purchaser of *West Penwith*, that it formed a dialectical pair with *Portreath*. Where *West Penwith* is exaggeratedly horizontal, flowing and indeterminate, *Portreath* is squat in format, a bird's-eye view of the sheltered harbour and town, which are depicted with almost hard-edge clarity. A bright red patch records a small hut on the quay, a single startling flash of colour, which is the focus of the painting. In its rigorous emphasis on appearance, *Portreath* is distinct from the bulk of Lanyon's paintings: it is as if with this pair he set out to measure knowledge against imagination and precision against ambiguity, to discover which approach best conveyed his perceptions of a place.

The emphasis on landscape in *West Penwith*, together with the earlier conflation of human and natural fecundity in the 'Generation series', suggest that in the late 1940s Lanyon was working out an equivalence between landscape and the body. If *West Penwith* is turned upright it looks like an etiolated human being, facing left, with its left hand clenched at its side. *North* (1949; private collection), which is also based on an elongated spiral, is one example of a group of paintings made in 1949–50 in which the conformations of landscape parallel those of the human body.

Both *North* and *West Penwith* were in Lanyon's first solo exhibition in London at the Lefevre Gallery in October 1949. This was an important opportunity to expose his work to a larger public and wider critical scrutiny than St Ives could provide. Reviews, sparse but favourable, inevitably linked his 'slim, cool, near-abstractions'[12] with Cornwall, a tendency that Heron, his earliest and most loyal supporter, turned tartly to account with the comment that they contained 'none of the modern French clichés'.[13] One of Lanyon's most severe critics, David Lewis, later curator of the Penwith Society, singled out *West Penwith* and *Portreath* as revealing an original and articulate painter but found the 'Generation series' derivative.[14] In view of its formal debt to Gabo this may be justified, though the psychological and emotional content of the 'Generation series' goes far beyond formal mimicry. This first London show initiated a very active exhibiting career, which Lanyon pursued in tandem with his involvement in the local, Cornish art milieu.

A corollary of Lanyon's personal attachment to place was his belief in the value of a dynamic local exhibiting society as a catalyst to intense, focused activity among artists. He felt that if such a society were not democratic it was not worth supporting; in practice this meant that all the members should be able to show their work on equal terms, without the intervention of a jury. Lanyon was not one who stood on the sidelines; acutely conscious of his

27
Construction 1947
Plywood and aluminium
30.5 cm high
Private Collection

28
Portreath 1949
Oil on strawboard
50.8 x 40.64 cm
Private Collection

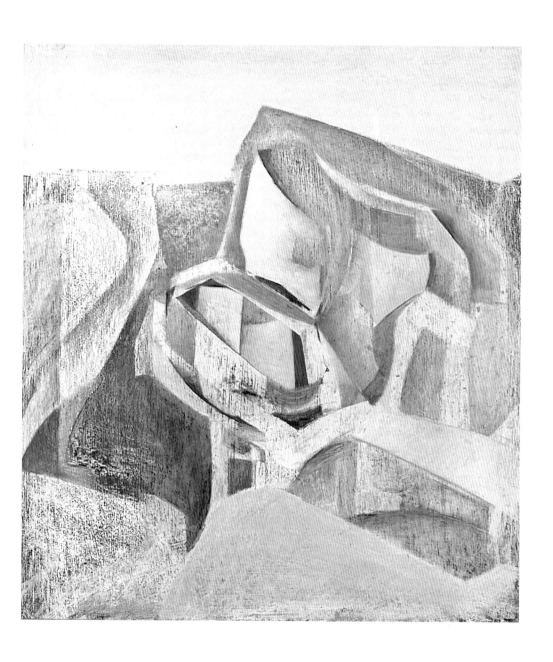

position as a Cornish-born artist and determined to extend the pioneering modernism of the Crypt Group, he threw himself into attempts to reform the old St Ives Society of Artists with reckless disregard for the repercussions on his relationships with colleagues.

Immediately before the meeting in the Castle Inn in St Ives in February 1949, at which the Penwith Society of Arts was founded, Lanyon, soon to be elected to the committee, was heavily involved in manoeuvres over its constitution. Founded on a wave of enthusiasm, with Herbert Read as president and the informal backing of the Arts Council, the Penwith Society seemed likely to foster much-needed links with arts administrators in London and beyond. It was therefore a devastating disappointment, as well as the cause of much personal bitterness when, in November 1949, deep rifts became evident. The reason for these was a decision, which originated in a proposal by Barbara Hepworth, for members' work and hanging committees, or exhibition juries, to be classified in categories that corresponded to 'representational', 'abstract' and 'craft'.

When the system came into operation the following May, Lanyon was among those who resigned from the Society, furious that what he saw as a restrictive and misleading ruling had been pushed through without adequate discussion. Most damagingly, he believed that Hepworth and Nicholson wished to control the society and thus the development of art in St Ives. As a result, he quarrelled violently with Hepworth and broke off relations with Nicholson. Three years later, in 1953, he was elected to the Newlyn Society of Artists where he immediately became active on the committee. He promoted the Society's exhibitions, encouraged members to show their work and brought arts administrators and distinguished visitors to the gallery. Sending-in dates for exhibitions were meticulously noted in his diary, for as Michael Canney, director of the Newlyn Gallery and Lanyon's childhood friend recalls, the eclecticism of the Society's exhibitions was an appealing counterbalance to the '"precious" abstractionism and modernism of St Ives'.[15]

Painful though the rift with Hepworth and Nicholson was, it was an additional spur to engage with a wider milieu and to develop a distinctive approach to painting. The Lefevre exhibition brought Lanyon to the notice of Philip James, director of Visual Arts for the Arts Council, who, in 1950, invited him to take part in *60 Paintings for '51*, the exhibition that was the Council's principal contribution to the Festival of Britain. It is historically important not least because it focused on young, advanced artists. Equally unconventional were the conditions for entry, which specified that paintings should measure a minimum of 40 by 60 inches, then considered an impractically large scale; because of the difficulty of obtaining still scarce materials, the Council undertook to provide free paint and canvas.

Lanyon's entry was *Porthleven* (fig.29). It did not win one of the five purchase prizes, but the Contemporary Art Society bought it and presented it to the Tate Gallery, where it is still acknowledged as a mould-breaking interpretation of landscape. It was the first of three paintings, all eight foot by four, in which Lanyon explored different aspects of his environment. Their over life-size scale is significant: it represents a space into which even a large man might fit comfortably, for the painted space was increasingly becoming that of his own body.

The subject of the painting is the complex harbour, with its three basins, at the centre of the town of Porthleven. At the top, the church tower (allegedly

29
Porthleven 1951
Oil on masonite
244.5 x 121.9 cm
Tate Gallery

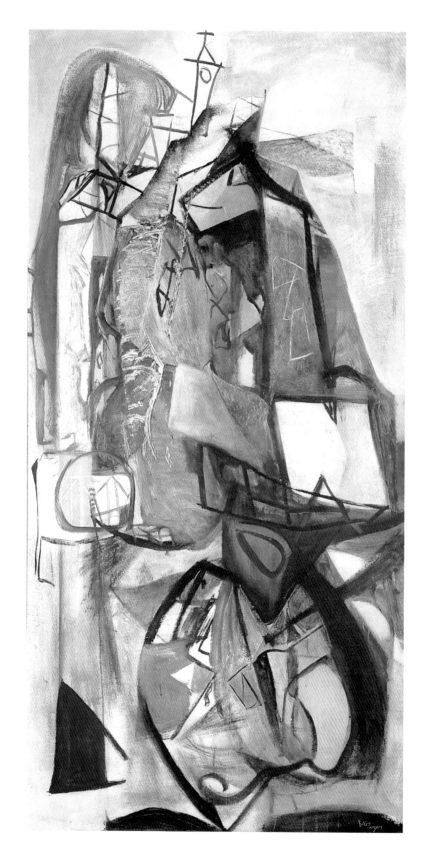

derived from a pepper-pot) is depicted in elevation, while the harbours are shown, extending below the church, as if in plan, a vertiginous combination of viewpoints that defies conventions of space and gravity and makes it impossible for the viewer to relate spatially to the painting.

A sense of disequilibrium was, it seems, precisely what Lanyon hoped to engender. He felt that a reciprocal energy flowed between his paintings and those who looked at them, so that, in effect, an image was only completed by a viewer's reaction to it: 'A picture can set somebody going ... and then they become, as it were, the person who is acting this picture out'.[16] In a lecture that he gave in 1963, in which he summarised ideas formulated over many years, Lanyon said 'I like to paint places where solids and fluids come together, such as the meeting of sea and cliff, of wind and rock, of human body and water'.[17] The vertigo and sense of treading a dangerous edge that such places generated were physical and psychological preconditions for being able to paint. If people experienced the same effect when they looked at his works, this confirmed for Lanyon that he had succeeded in communicating an idea through an image.

More than a year before he began *Porthleven*, Lanyon wrote an essay called 'Time, space and the creative arts'. In it, he discussed the difficult ideas that he wished to convey in paint, of being simultaneously present in a single place and moving around it in space, with his vision constantly changing. He wrote of the abrupt readjustment needed when, standing on a cliff edge, looking down at the sea crashing onto the rocks several hundred feet below, he lost his sense of balance. In *Porthleven*, Lanyon's precarious stance on the cliff-edge is transformed into the way in which we see both from above and frontally, combining experiences which, if real, would be separated in space and time.

When the painting was completed Lanyon realised that it contained a pair of half-concealed human figures. Up the left-hand side stretches a tall, thin man, holding in one hand a lamp, which is also the church. On the right is a woman, her rectangular face, with a mouth and eye, just below the church. She is wrapped in a shawl, her billowing skirts enclosing the inner of the three harbour basins. Lanyon insisted that the figures in *Porthleven* had emerged during the painting process without conscious premeditation, though he acknowledged that their appearance had alerted him to one of the most prominent themes in his work.

Porthleven took over a year to make. So obsessively did Lanyon rework it that he damaged the canvas irreparably and was obliged to repaint the final version on masonite board. He did so in a few hours, producing a spontaneous, fresh summary of a complicated creative process that had involved numerous sketches and constructions. Cartographically precise line drawings, scratched into waxed paper, provide insights into his choice of viewpoints. The church and the end of the harbour breakwater are drawn so as to convey the maximum amount of information in the most economical way: the former is seen in characteristic silhouette and the latter from above, to show the flow of water through the harbour basins.

The constructions, quite different from any that Lanyon had previously made, were contraptions of painted wood and metal, tacked together and precariously balanced. He considered them simply as aids to painting: 'to establish the illusion and the content of the space in the painting', he commented.[18] Constructions like *Porthleven Boats* (fig.30) helped him to

30
Porthleven Boats
1950–1
Oil paint on wood
and sheet metal
62.9 x 35.9 x 41.9 cm
Tate Gallery

analyse space, colour and scale as seen and sensed by a person in movement in order to reduce the multi-dimensional complexity of a place to paintmarks on a flat canvas. Though such constructions are not realistic, they replicate the constant, unconscious adjustments and comparisons of one's vision as it seeks to make sense of an environment.

It was clear to Lanyon that *Porthleven* was radically different both from conventional landscape painting and from fashionably flat abstract painting like Ben Nicholson's still lifes. He was well aware that the direction he had mapped out for himself would not be readily understood. The rationale of his painting process depended on the viewer's willingness to accept that the artist might be present, though not represented, in his paintings in the same way that elements of landscape were present, though not directly copied, as they would be in an academic painting. 'Obviously the so called reality of static nature which is still believed in by Royal Academicians will not be the reality which the artist wishes to represent, but the reality of space-time in which he himself exists as much as the objective facts (sea and rock) of the world and life', he stated.[19]

While he was painting *Porthleven*, Lanyon began to teach at the Bath Academy of Art at Corsham in Wiltshire. Like his fellow artist-tutors, he was given a studio and encouraged to develop his own work as an essential component of his teaching. With his students he extended the processes he had already adopted in order to familiarise himself with a place. He would take students out into the countryside, make them lie down in the grass to see a view from below, walk around rocks to observe their shapes from behind, and even paint on the ground itself. In this way he demonstrated his understanding

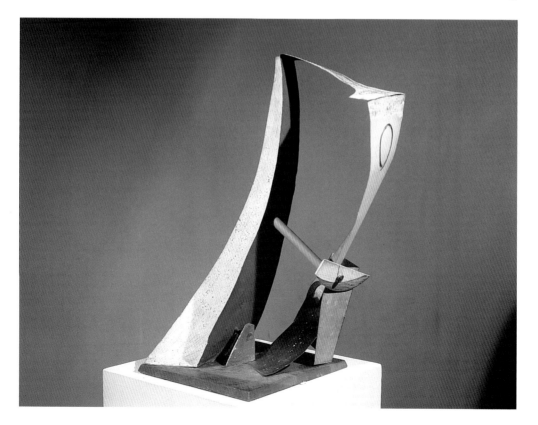

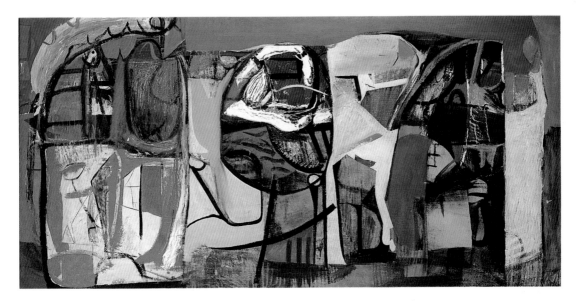

of landscape as a sensory environment, to be felt, smelled and heard.

When Lanyon was teaching he would spend weeks at a time based at Corsham, taking the opportunity to paint intensively. However, he disliked the Wiltshire landscape, so that the landscapes he painted there tended to be of Cornwall. He turned his distaste to good account by developing a figure-painting practice. Since life drawing was an important aspect of the curriculum Lanyon was able to make many drawings of the models employed by the school. Initially, he treated landscape and figure painting as distinct practices, but we shall see that they rapidly merged into a single imagery in which they became indistinguishable.

Whereas *Porthleven* is concerned primarily with the sea as a force that dominates the small town, for his next two large paintings, *Bojewyan Farms* (fig.31) and *St Just* (fig.7) he drew on the experience of immersion in the landscape that he played out with the Corsham students. *Porthleven* and *St Just*, which both explore psychological and emotional relationships with places, are vertical in format, inviting comparison with the human body, whereas *Bojewyan Farms*, 'a farmyard … which really stinks of dung',[20] has the classic, horizontal landscape format.

This painting was the centre-piece of Lanyon's second solo exhibition in London, held at Gimpel Fils in March 1952. It is named after an area of farm land, broken up into a mesh of ancient fields, which lies close to the coast between St Ives and Botallack. Like the paintings of Ivon Hitchens, which Lanyon admired, *Bojewyan Farms* is divided horizontally into three sections. In the central one a head-like shape, which is closely connected to one of Lanyon's constructions, overlies 'some sort of animal'.[21] On the left, in the familiar combination of plan and full-face views, are a stretch of water and fields, abutted by a half-hidden human figure, which merges into field green. On the right is the rich red-brown associated with tin-mining. Identifying also 'the chaff which comes from corn and harvesting', Lanyon concluded 'it's a picture about birth and life and death'[22]: a natural cycle in which we all participate.

Towards the end of 1952, Lanyon announced in a letter to Hitchens, 'I have just constructed and executed Christ and the result is like the residue of a

31
Bojewyan Farms 1952
Oil on masonite
129 x 243.9 cm
The British Council, London

32
Construction for St Just 1952
Glass, paint and Bostick
65.3 x 28.4 x 25.5 cm
Private Collection

NAPALM bomb. There is no sign of him but he is everywhere and there is a queer light. I think I have at last painted a picture with *no colour* like glass'.[23] He was referring to *St Just* (fig.7), the most richly allusive of all his paintings. The subjects of the painting are the small, grey, granite town, St Just, which has a Wesleyan amphitheatre at its centre, and a notorious mining disaster that occurred in 1919, when thirty-one men were killed by defective machinery in the nearby Levant Mine. The painting is intensely Cornish, historically specific, a protest against exploitation and greed, combined with a Christian theme.

A central black shaft dominates the canvas, emerging at the top into a linear mesh. It stands both for a mineshaft, topped by pithead machinery, and a crucifixion with the Crown of Thorns at its apex. Round the perimeter of the canvas run little fields and buildings, seen in bird's-eye view, rather as Alfred Wallis might have painted them. Two figures, half buried in thick paint, flank the central shaft: on the right is a woman, spread-eagled, her feet submerged in the sea at the base of the mine. On the left is a man, grey and straight, most clearly identified by his rib-cage.

While he was working on *St Just,* Lanyon made his most dramatic construction: a vertiginous edifice, like a house of cards, of fragile sheets of plain glass, held together with Bostik and balanced around an empty centre. Other than slivers of green and mauve, the only colour is black, applied in dense scribbles, some of which echo the rib-cage in the painting. Just as a version of the construction *Porthleven Boats* can be recognised in a curved form near the centre of the 1950 painting, the flat sheets of the *Construction for St Just* (fig.32) are detectable in an area of outlined green shapes towards

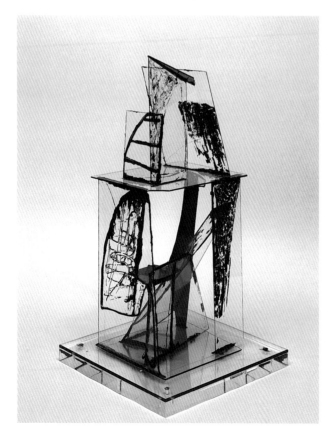

the top right of the canvas. The construction has a poignancy that lifts it far beyond its initial role as an aid to painting, for it evokes human frailty and death, recalling Lanyon's comparison between painting and climbing a mineshaft 'away from a tomb'. It seems likely that in the painting and the construction we see Lanyon's own shadowy presence, indicated by the dense black markings on the glass.

The foot of the shaft runs into the sea, a mingling that refers to a fundamental aspect of Lanyon's personal mythology: he understood the land as female, fecund and reproductive and the sea as a male, penetrative element; its constant incursions into the mines and the coast are eminently visible all around Cornwall. Bearing this symbolism in mind, we can better grasp the complexity of *St Just.* The mine, once a source of wealth that represented the survival of its workers, belongs to the land and to

Cornwall and is capable of regeneration, or rebirth, in a faint echo of the human redemption promised by Christ's death on the cross. *St Just* is sometimes described as a memorial painting but, though it obviously contains an element of elegy, this is to ignore its central, passionate and political protest against man's inhumanity to man.

St Just completed an unplanned trilogy of interlinked paintings, each of which focused on a specific aspect of Lanyon's environment. Sea, land and 'things under the soil'; fishing, farming and mining; life and death; myth and religion were the complex matter of these paintings: it should come as no surprise that they remain challenging and difficult to interpret.

The thematic connection between land, fertility and Christianity was restated in Lanyon's scheme – never put into practice – for displaying *St Just*. It was to be at the centre of a polyptych, with *Bojewyan Farms* as a majestic predella. Some years later Lanyon stated: 'I painted two tall pictures to go on either side. They were landscapes but they were also mourners on either side of the cross.'[24] He identified these paintings as *Harvest Festival* and *Green Mile* (both 1952; private collection). Though their dimensions are not identical the deliberate mismatch confirms that the polyptych was a gathering of themes, rather than of works, though it has subsequently been suggested that he may have intended *Corsham Towers*, which is the same size as *Harvest Festival*, as the second side panel. Like *Green Mile*, it suggests a standing figure, or watcher, as well as a landscape, while the title *Harvest Festival* implies regeneration or rebirth.

Early in January 1953 Lanyon set off for Rome, on an Italian government scholarship that kept him away from Cornwall until April. Some of this time was spent painting at Anticoli Corrado, a village near Rome from which he explored the ancient walled towns of the area. He became a fascinated observer of Italian peasant life and rituals.

Lanyon described his experiences in numerous letters, though their impact on his paintings only became evident the following year, leading to changes in format, subject matter and colour. *Sarascinesco* (fig.33) takes its title from a small walled town, reached after a two hour walk along a mule track. The town reminded him of Cornwall, and the painting echoes *St Just* in its conflation of Christian imagery with a singular place, for Lanyon associated it with the Flight into Egypt and Christ's entry into Jerusalem. Multiple viewpoints allow us to look down into the walled town with the Abruzzi mountains behind it. At the top left, the mountains double with the shape of a donkey, a descendant of one that Lanyon had made the previous year in plaster. Counteracting the greyish ellipse of the walls are three strong verticals that rise like human presences from the fabric of the buildings.

The unusually bright, rich colours of *Sarascinesco* – which include a small area of gold-leaf, perhaps a tribute to early Italian painting – is even more dramatic in *Europa* (fig.34), which is grounded in the myth of Europa and the bull. Before starting it, Lanyon made a new kind of construction: a free-standing sculpture in plaster and metal, to show how Europa was folded within the body of the animal. Its heavy, compact form is echoed by the painting, where the white area at the top left stands for the combined figures of girl and beast. The rich red ground was inspired, Lanyon wrote, by a custom that he had observed in Italy, 'of hanging out a red blanket after the wedding night'.[25]

33
Sarascinesco 1954
Oil on masonite
127 x 122 cm
City Museum and Art
Gallery, Plymouth

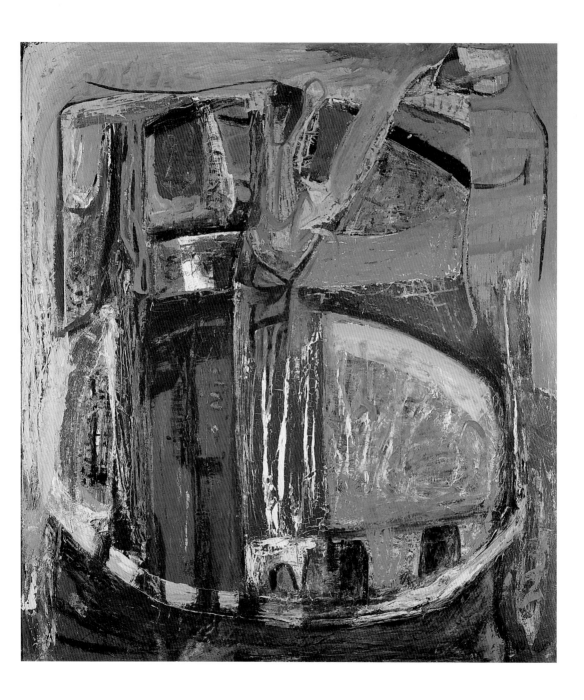

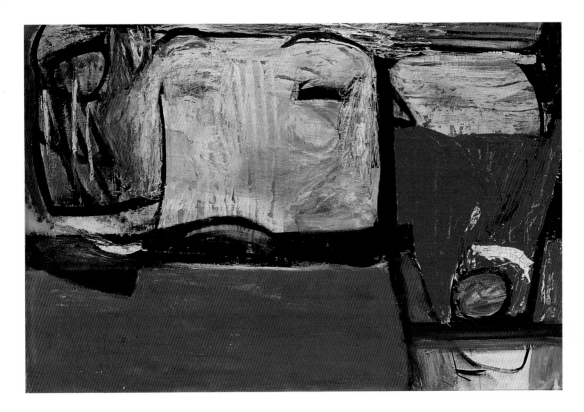

The thematic complexity of *Europa*, in which Lanyon collapsed time to combine ancient myth and modern eroticism, mirrors that of his landscape paintings and underlines the way in which he reworked and developed his themes: Europa herself naturally replicates the female land, while the bull can be equated with the uncontrollable, destructive male force of the sea. The painting and its myth transposed to other contexts as readily as the inner and outer landscape theme, serving as the source of a number of very different images. As we shall see, Lanyon felt that the myth contributed to *Offshore* (fig.42), while the basic shapes of *Europa* were repeated in *Beach Girl* (fig.35), a painting of a sunbather turning over in a flurry of sand. In *Untitled (Sunday)* (1962; private collection), where Lanyon painted a woman's body in the colours of sand and rock, he once again echoed the solid masses of *Europa* and the sense of a white shape emerging from the sea to encroach on the land.

Europa and *Sarascinesco* are both connected with narratives deeply embedded in European culture and with a mythic past in which animals and humans had interchangeable attributes, as they did in *The Yellow Runner* (fig.18). The two paintings contribute to what Andrew Causey has called a 'pantheistic undercurrent' in Lanyon's work, 'a concept of life in which gods, men and animals are less completely and permanently differentiated than they are in our own thought and beliefs'.[26] Italy provided Lanyon with the stimulus of a strange culture, which he was able to combine with themes from his own, earlier work. *Sarascinesco* thus retains the multiple viewpoints, enigmatic figures and animals in stockades, to which were added the fresh experience of a fortified hilltop town, a clearer, brighter light and a strand of Christian imagery in which donkeys played a leading role.

Though *Europa* was startlingly different from earlier works, it extended

34
Europa 1954
Oil on masonite
122 x 182.8 cm
Private Collection

35
Beach Girl 1961
Oil on canvas
106.7 x 152.4 cm
Private Collection

Lanyon's theme of birth and regeneration, combining it with his new-found enthusiasm for figure painting developed at Corsham. Here, before leaving for Italy, he had encountered the work of a French student, Marie-Christine Treinen, who had probably had some contact with the paintings of Jean Dubuffet, which were still little known in Britain. Her drawings bore a marked resemblance to Dubuffet's representations of the human body as a squat, baggy torso with rudimentary head and limbs. She drew the female body as a crude, sagging rectangle, with a circle for the head and angular stick-limbs. Several of the tutors at Corsham were fascinated by the power and unabashed sexual implications of Treinen's drawings. William Scott, who was Master of Painting until 1956, converted her figures into still lifes, where a table-top stands for the torso of a woman, reduced to a rough rectangle. In *Levant Old Mine* (fig.36), Lanyon adapted Treinen's figures to his own body-in-landscape theme. Less obviously human than the figures in *Porthleven* or *St Just*, these ambiguous signs for bodies were to recur throughout his career.

Through much of 1954 and 1955 Lanyon suffered acutely from depression and produced few paintings. Sales were also painfully sparse. 'Italy', he wrote to Peter Gimpel, 'has helped a lot but financially it has been disastrous'.[27] Once he had worked through the stimulus of the Italian trip, he returned to the local landscape in paintings like *Moor Cliff, Kynance* (1954; Arts Council Collection) and *Mullion Bay* (fig.37). Sombre, almost static renderings of the weight of rock and soil, they are surprising reversals of the dynamism of *Europa*,

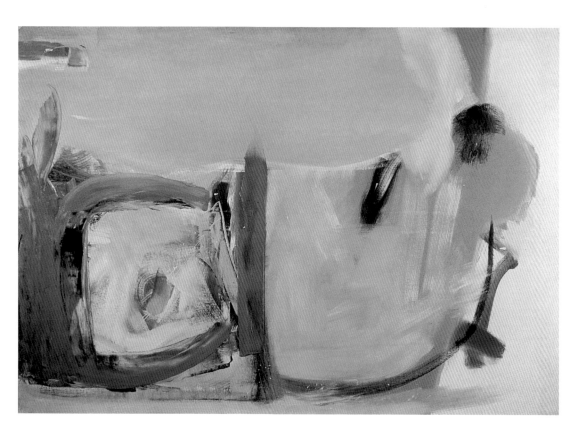

suggesting a deep dilemma as to how to develop his work. A second exhibition at Gimpel Fils in the spring of 1954 received a mixed response: praise was countered by waspish comments and incomprehension, which even led one critic to resort to the old chestnut: 'less communicative than most work in children's exhibitions'.[28]

In 1955, perhaps as a distraction from the intractable problems of painting as much as a money-making venture, Lanyon opened an art school, St Peter's Loft, in the large space above the Penwith Gallery in St Ives. His partner in the venture was William Redgrave, who is said to have been 'aggressively anti-"abstract"',[29] and gave classes in life drawing in his own studio. Similarly, the sculptor Denis Mitchell taught printmaking in his studio. Lanyon was the dominant personality in the school where, a former student recalls, 'he put *all* his energies into encouraging and teaching us … probing everyone to advance their own style',[30] rather than try to produce Lanyon-like paintings. There were echoes of Corsham too: 'he would take us down to the beach and draw a horse or a bull maybe a hundred yards long'.[31] Though the school continued until 1960, it became more formal after the first exuberant summer, with foreign students often referred by the British Council.

Unconventional in so many ways, in studio practice Lanyon was a traditionalist. One ex-student recalls rigorous tuition in basic craft techniques and Lanyon's 'delight in gesso ground, size, rabbit-skin glue'.[32] He ground his own pigments, obtained from Cornelissen, the artists' supplier in London, and prepared the gessoed boards on which he painted until the late 1950s. When he began to sell in the United States, the tendency of New York's central

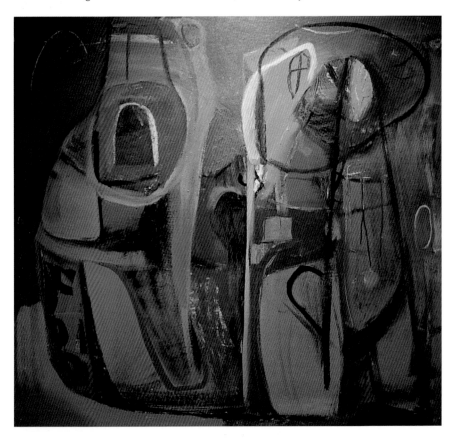

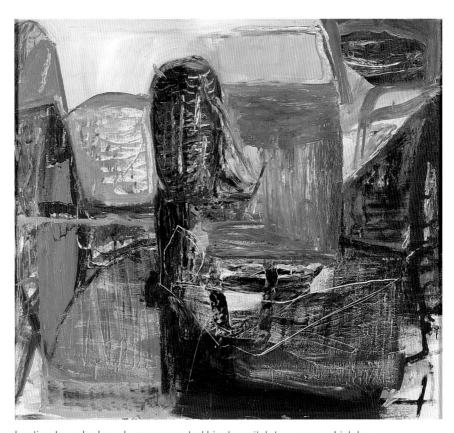

36 *Left*
Levant Old Mine 1952
Oil on masonite
119.4 x 127 cm
Private Collection

37
Mullion Bay 1954
Oil on masonite
152.4 x 152.4 cm
National Gallery of Victoria,
Melbourne (Felton Bequest)

heating to make board warp prompted him to switch to canvas, which he bought in St Ives and stretched himself. Still there were worries about the cracking and damage caused by rolling a painting because 'I *hate* to think I am painting on a ground which won't last … I don't like making a "temporary" thing'.[33] A year or two later he began occasional experiments with acrylics, but he found them 'slick and dead'[34] and continued to prefer oil paint. For some years he also made his own, usually unpainted, frames, though later he opted for those made by 'the local builder's carpenter'.[35] No doubt the labour of gessoing boards and grinding pigments avoided waste and allowed him to achieve nuances of tone not possible with commercial colours, but probably more important was his physical involvement at every stage of making a painting.

By 1956, in the eight years since the 'Generation series' Lanyon had evolved a way of painting landscape in which imagination, real places and the human body were of equal importance. In the late 1950s his understanding of the relationship between space and the places within it was to change again, as radically as it had a decade earlier.

3
'High places and edges'[1]

During the later 1950s, marked changes became evident in Lanyon's work. His first sustained encounter with modern American painting took place at this time, followed by his entry into the American art world, when he began to show in New York. Although he continued to paint landscape, remaining as much 'a place man' as ever, many of his works were effectively airscapes or syntheses of his visual experiences in the air after he took up gliding in 1959. A personal turning point came in September 1956, when the Lanyons bought Little Park Owles, the house that had belonged to Adrian Stokes. While the move may have helped to end the depression from which Lanyon had suffered during the previous two years, it also initiated a new phase in his life. The house had been a centre for the advanced artists of St Ives fifteen years earlier. Now Lanyon was himself one of the leaders of his own generation and poised to become a mentor for young artists.

Early in 1956 a survey exhibition of twentieth-century American art, called *Modern Art in the United States*, opened at the Tate Gallery in London. A single room was devoted to work by Abstract Expressionist artists, who included Willem de Kooning, Robert Motherwell, Jackson Pollock and Mark Rothko. Contemporary American art was then almost unknown in Britain, though it was a subject of intense interest to artists. Like a number of his colleagues, Lanyon had already encountered isolated aspects of American painting. He had seen the paintings by Pollock in Peggy Guggenheim's collection when they were shown during the 1948 Venice Biennale. No doubt he had heard his friend and colleague William Scott describe his visit to the United States in 1953 and he is likely to have seen reproductions in art magazines, but none of this amounted to more than a scant introduction to the range of work produced by the New York artists.

Like many ambitious painters of his generation, Lanyon was strongly affected by the American exhibition. Its most obvious impact on his output is evident in the way that the texture of his works changed from almost sculpturally thick paint to long, dry, semi-transparent marks that convey the sensation of wind, rain and the vagaries of weather. In *High Ground* (fig.38) he combined thick and thin paint to convey the idea of 'Blown grass on the high hills of the backbone of Cornwall'.[2] In this combination of petrified solidity and evanescent effects, 'small details of paint are set off by a slow pulse of blocks and a diagonal'.[3] The diagonal, soon to become a central compositional feature, tells us that we are looking down, perhaps from an impossibly high point for an earth-bound painter. Lanyon later said of *High Ground*: 'the diagonal lifts me from the ground into the sky. About this time I discovered I could do exactly this. I saw three gliders over a cliff and decided to go up there myself.'[4]

38
High Ground 1956
Oil on masonite
122 x 182.9 cm
Whereabouts unknown

Lanyon began to work from a single, almost aerial viewpoint, looking directly downwards, as if from an aeroplane, some time before he actually started gliding. Though the experience of flying dramatically changed the appearance of his paintings, the idea had grown out of his earlier work in which he had explored the landscape from every possible angle. It was a way to retain a recognisable subject and, at the same time, to distance the painting from it. In images such as *Rosewall* (1960; Ulster Museum, Belfast), we are aware, firstly, of the diaphanous quality of the paint, which suggests a deep space beyond its surface. Gradually we recognise within this space a figure or wind and movement, ambiguous subjects that have no frontal view.

Like many of the paintings that Lanyon made between 1957 and 1959, *Silent Coast* (fig.39) acknowledged American Abstract Expressionism, while remaining distinct from it. A view of the coastline from above, it is replete with the colour of sea and sky in high summer, when the air is heavy with heat, stopped in a moment of silent beauty. The blue swells, like the belly of a pregnant woman, to cover the field green along the coastal strip. With its hint of the fecund body, *Silent Coast* may be seen as a reinvention of a constant theme, while its shimmering colour proclaims Lanyon's debt to Mark Rothko, whose paintings he saw in 1956.

With *Lulworth* (fig.40), Lanyon revisited the body as landscape. Rock-like shapes in the colour of Dorset chalk double as a pair of human figures, formed by dramatic black marks, made with the sweep of an arm and a mass of fine, scratched lines. Like a visual diary entry, *Lulworth* records a private incident. It represents, as Lanyon explained: 'two lovers standing up hugging one another

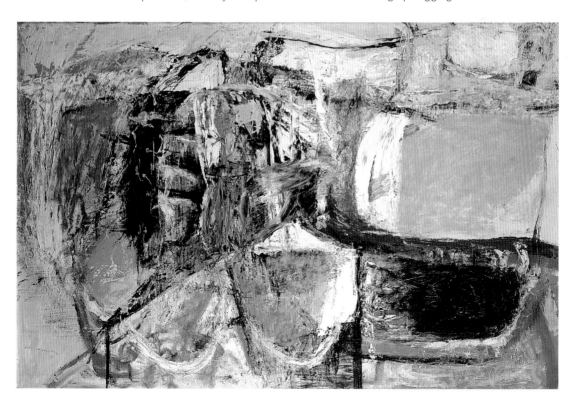

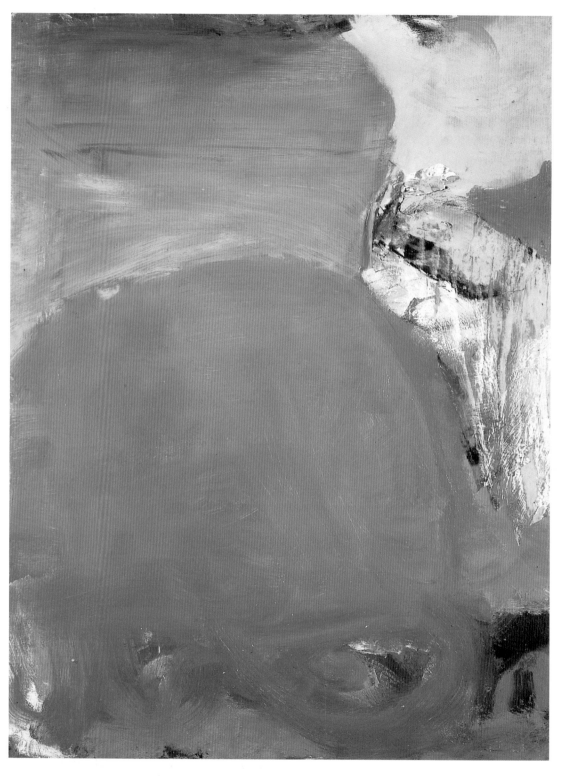

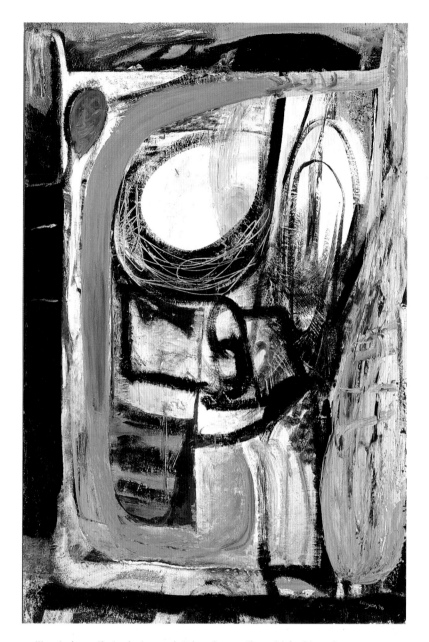

39
Silent Coast 1957
Oil on masonite
136.3 x 102.2 cm
Manchester City Art
Galleries

40
Lulworth 1956
Oil on masonite
182.8 x 119.3 cm
Albright-Knox Gallery,
Buffalo, New York. Gift of
Seymour H. Knox 1958

waiting to have their photograph taken by a rather old-fashioned
photographer who's on the left-hand side of the picture'.[5] It has been
suggested that the construction *Playtime* (fig.41), which is composed from an
apparently random scatter of inconsequential objects, echoes a similar,
semi-urban landscape, filled with people and chance encounters.

Early in 1957 Lanyon travelled to New York for his first exhibition in America,
at the Catherine Viviano Gallery. Viviano already represented Alan Davie and
was at the forefront of a wave of interest in such younger British artists as
Richard Smith, Patrick Heron and William Scott. This opportunity promised to
be the breakthrough, in terms of recognition, for which Lanyon had waited so
long. He took a term off from Corsham to prepare for the exhibition, a burst of
energy in which he conclusively set aside the problems of the preceding two

49

years. He showed sixteen paintings, which remained in America to be sold in the future, and received some favourable reviews. The most significant aspect of this first exhibition in the United States was the opportunity it provided to make contact with American artists. Lanyon's engagement diary for the ten-day visit indicates that he met the painters Robert Motherwell and Adolf Gottlieb; the dealer Martha Jackson; the critics Dore Ashton and Clement Greenberg, who was the *eminence grise* of the New York School, as well as the collectors Richard Baker and Stanley Seeger, who was to become his most devoted patron. There is little documentary evidence of his relationships with the New York painters, though we know that Motherwell and Rothko later spent occasional weekends at Little Park Owles on their trips to Europe and that de Kooning also became a valued friend.

Art historians have discussed the relationship between the paintings of Lanyon and de Kooning and some have even described Lanyon as an Abstract Expressionist. This is, however, misleading. Undeniably, there is an affinity between their paintings and certain similarities between, for instance, the sweeping marks and thin overlays of pigment in Willem de Kooning's *Easter Monday* (1955–6; Metropolitan Museum of Art, New York), which Lanyon could easily have seen, and the way in which Lanyon himself laid down paint in canvases like *Offshore* (fig.42). However, there were fundamental differences between their understanding of landscape, of their own place within it and, not least, between the actual landscapes of Cornwall and North America.

Though Lanyon set off again less than a month after his return from New York, to revisit Rome, Anticoli Corrado and Sarascinesco, his axis was increasingly to run between Cornwall and the United States. A second exhibition at the Catherine Viviano Gallery took him back to America in January 1959. Another hectic round of engagements took place, when he met, besides old acquaintances, Helen Frankenthaler, Hilton Kramer and James Johnson Sweeney. If painting was never going to be easy, Lanyon knew, by the time of his first American show, that he no longer had cause to agonise, as he had in 1949, 'My instruments are so poor for what I have to express'.[6] The practised artist of the late 1950s had attained a fluency undreamt of a decade earlier, spurred on by the urgency of requests to show his work.

In July 1957 Lanyon took part in a Third Programme radio broadcast with the painter, Anthony Fry and the critic, Andrew Forge. He described a trip to the Peak District in Derbyshire, in preparation for a painting called *Highlow*. This involved 'kneeling on the edge of a 200 foot drop' to make a drawing, a process enhanced by an imminent sense of personal danger. Explaining the role of such a drawing in bridging the distance between the vertiginous view

41
Playtime 1964
Mixed media
137.7 x 39 x 10.6 cm
Private Collection

42
Offshore 1959
Oil on canvas
152.4 x 182.9 cm
Birmingham City Art
Galleries and Museum

down a cliff-face and a flat canvas, he said: 'I am to make a sign. I may draw direct, without observation of the place *but in its presence*. The drawing may be a doodle to reveal the condition of the developing image, sharpening a loosely experienced left side or defining a shoulder … I now conceive the vertical form as part of myself to be painted by *physical involvement*.'[7]

Lanyon clarified these ideas when, in the course of painting *Offshore* two years later, he recorded its development as he worked. He related how he walked, in a north-easterly gale, along the beach towards one of the hills that shelter the harbour of Portreath, climbed the hill to watch the sea, now under his feet, then lay down on the grass to shelter from the wind. The crucial event came towards the end of the painting process, when the orientation of the canvas changed from vertical to horizontal, so that the former base became the right-hand side. The vertical state, Lanyon wrote, 'described the place, the sources outside me, from which the painting derived'. At this stage it contained two notional figures, the masculine sea and the feminine land, which he compared with *Europa*, 'where the sea was on top and the female form inshore'. Concentrating intently, he bent over to the left and almost overbalanced. Laying down the white area, now in the bottom right-hand corner, was 'the final push, that turned the painting over on its side'. The sequence of events, from climbing the hill, to a sense of acute imbalance, was

the result of a 'process which, starting with an extreme awareness of oneself in a place, ends in an extreme awareness of oneself in painting'. Only when the two fused was the image complete.[8]

Late in 1959 Lanyon began gliding. He received his licence the following summer. It became a passion, the resolution of his long frustration during the war. It also became the focus of his painting. The gliding paintings can be identified by their titles, which refer to specifics of flying and meteorological conditions. One of the earliest is *Soaring Flight* (fig.43), which refers to the action of the glider as it mounts in a spiral on the warm air-current of a thermal. Like *Silent Coast* it is dominated by a luminous blue, which suggests layer upon layer of translucent colour that may be drawn aside to reveal what lies below. As we watch the painting, we are pulled into its centre; we rise up the left-hand side, along the scarlet streak that marks the path of the glider,

43
Soaring Flight 1960
Oil on canvas
152.4 x 152.4 cm
Arts Council Collection

44
Cross Country 1960
Oil on canvas
180 x 216 cm
Private Collection

then turn: 'one almost stays', Lanyon commented, 'in the inverted V'.[9] We can imagine that it is possible to see below the diagonal, peer vertically down at a patch of field green, then turn abruptly to follow the rapid brown lines at the bottom of the canvas.

Cross Country (fig.44) describes the very different activity of extended horizontal flight. Sky, land and sea are laid out in three broad bands, overpainted with black swathes that show the course of the aircraft, crossing and recrossing a territory, in what might be seen as a mapping of the memory of the journey. Weather is less prominent here, though there are hints of turbulence and of sea-spray. A crucial piece of information for any pilot is the precise height of the cloud base, the point where a bank of cloud will cut off visibility. In *Cloud Base* (1962; private collection) we see the dense white mass from above, with clear air on either side, and also from below, where it terminates against a precisely marked line, the edge that denotes danger, a moment of disequilibrium and decision.

The complexity of Lanyon's paintings, in which multiple viewpoints exist in parallel with many layers of meaning, should confirm that the gliding paintings are about more than weather and strangely angled views of the landscape. Alone in his single-seater glider, Lanyon was necessarily the only person able to register the sights and sensations that were the source of his imagery. Consequently, though he never depicted himself, his implied presence is central to all the gliding paintings, recorded by the marks that he made on the canvas: the great red, encircling track of the aircraft in *Solo Flight* (1960; Scottish National Gallery of Modern Art), or the zig-zag course shown in *Cross Country*. In the glider, Lanyon was able to reach higher places than ever before and, given the tiny space of the cockpit, into which he fitted like a canoeist, the edge became his own body aligned with the skin of the aircraft.

There is a further, speculative dimension to the gliding paintings. The modern artist was reinvented by post-war writers as an idealised, solitary

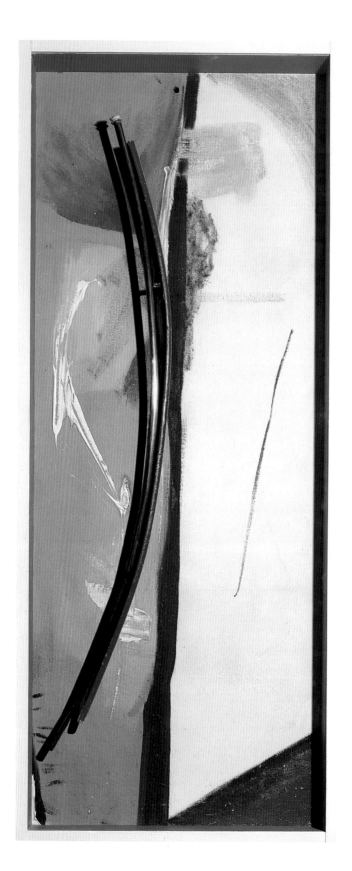

45
Coast Soaring 1958
Copper, wood and oil
on masonite
159 x 65.3 cm
Private Collection

46
Lost Mine 1959
Oil on canvas
182.8 x 152.4 cm
Tate Gallery

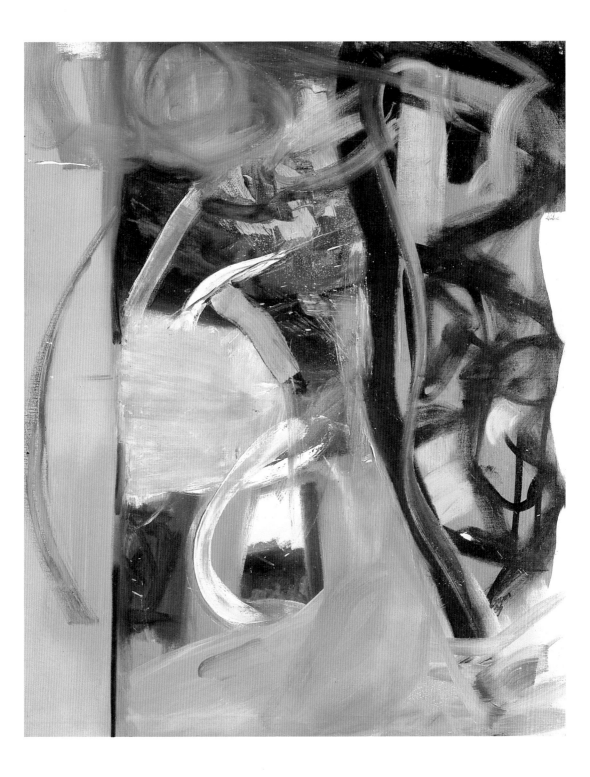

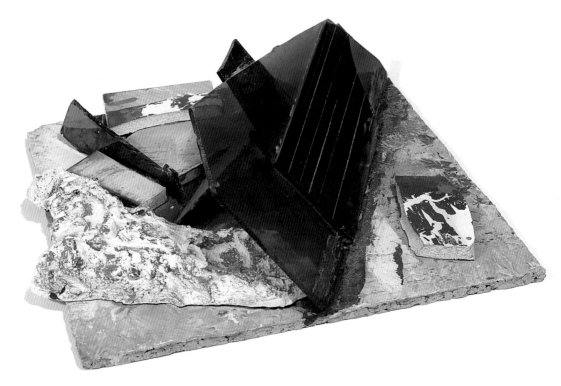

47
Blue Glass Airscape
1960
Glass, ceramic, plaster
and paint on cork tile
31.2 x 31.2 x 12.7 cm
Private Collection

figure, untouched by external forces, ideology or material needs: a privileged innocent required only to fulfil a personal vision. This absurdly over-simplified model replaced the older idea of the Bohemian, in order to represent the artist as a metaphor for a free society. Alone in his glider, answerable to no-one and performing great loops and arcs through the empty sky, Lanyon may be seen as the archetypal modern artist.

As well as paintings, Lanyon made many constructions connected with gliding. *Coast Soaring* (fig.45) dates from shortly before he took up gliding and conveys his anticipation of the concentrated, sustained thrill of flight. It is made of a length of copper tubing set beside a curved board, of which the outer edge is painted scarlet. Seen from the side, though, the board is white and covered with dense black marks like those on the *Construction for St Just*, with which he recorded his own presence. A shallow painted curve, very similar to the long arc in *Coast Soaring*, runs up the left-hand side of the painting *Lost Mine* (fig.46). This is a reverie on the remnants of a mine that was flooded by the sea and left to sink gradually into decay, in contrast with *St Just*, where Lanyon was concerned with a tragedy caused by human negligence. We see the lost mine of the title from the familiar aerial view, crossed by a thick black line that indicates the ruined shaft. The arc, set apart in an area of calm air, suggests both personal danger and the possibility of rising, through flight, above the zone of danger.

The constructions of the late 1950s took many forms: some, like *Blue Glass Airscape* (fig.47), are made largely of stained glass and are free-standing. Others, like the witty *Green Buoy* (1962; private collection), of which the focus is a nondescript plastic knob, are semi-pictorial, combining large areas of paint with little objects carefully selected for maximum impact. In *Turn Around*

(fig.48), Lanyon used scraps of disparate materials to explore complicated movements in space. A wooden plug protrudes from its centre, where it anchors a sheet of clear plastic, marked with a rough black arc, which runs down to the lower edge of the construction. Here he returned to the spiral, which may be followed in space as the eye travels down the black arc, into the painted surface and up the red curve to return to the densely marked figure-of-eight in the bottom right-hand corner, where it is framed, like a detail on a map, as though to emphasise a particularly intense moment.

By 1959, after two successful exhibitions in New York, Lanyon had become aligned, like many of his contemporaries, with American-oriented painting. He remained emotionally attached to Cornwall, however, even while he was convinced that in order to fulfil his ambition it was necessary to travel and expose himself to new places and fresh stimuli. In the late 1950s, British art, in David Thompson's words, began 'seriously entering the international lists and winning prestige for itself'.[10] Lanyon was part of this process. Though his oil paintings were still too advanced for many collectors' tastes, he was regularly invited to take part in British Council touring exhibitions and events at the cutting-edge of contemporary art.

At home, Lanyon won the second prize in the 1959 John Moore's exhibition, a showcase for leading contemporary British artists, with *Offshore*. The following year, the Arts Council commissioned him to make a construction for the exhibition *Modern Stained Glass. Colour Construction* (fig.49), which is roughly pyramidal and internally lit, was much larger than any of Lanyon's previous constructions and the first, since 1947, that he had made as a work of

48
Turn Around 1963–4
Plastic, polystyrene,
glass, wood, oil and
masonite
73.8 x 66.7 x 8.5 cm
Tate Gallery

art in its own right. This piece not only provided numerous off-cuts that he used for smaller constructions, like *Blue Glass Airscape*, but also involved learning the technicalities of producing stained glass. Like a three-dimensional version of *Soaring Flight, Colour Construction* contains an interior structure of overlapping coloured planes, which change constantly as the viewer moves around the piece.

Lanyon undertook three more commissions in the early 1960s. They were all for murals, in which he was able to explore the idea of landscape as part of a larger environment more directly than in smaller easel paintings. *The Conflict of Man with The Tides and Sands* (fig.50) was made for Liverpool University's Civil Engineering Building. *Delaware* was commissioned by his patron, Stanley Seeger, for his house in New Jersey. Lanyon's final mural was painted for the Faculty of Arts at Birmingham University (fig.51). In each case the scale allowed him to construct images that approximate to narrative progressions through space and time. Set against this unprecedented freedom were the demands made by specific sites and the requirements of the patrons.

Lanyon pondered these preconditions uneasily, since he felt that to work to a stipulated subject would restrict his normal process. The public mural, he felt, ran the risk of being either extremely generalised or narrowly didactic. Conversely, it might become simply a formal exercise in spatial illusion. Fortunately, the experience of the first, Liverpool, mural persuaded him that these problems could all be resolved, despite considerable technical difficulties, because he was working with architects sensitive to the methods of painters and sculptors.

The Liverpool mural was commissioned by Maxwell Fry of Fry, Drew and Lasdun, a practice that had long made a point of working with artists. Title, site and medium were stipulated: the mural is made of porcelain tiles, painted with enamel colour and fired. In order to research the subject – broadly, the movement of waves and consequent changes in river-beds and estuaries – Lanyon visited the Hydraulics Research Station where he saw models built to simulate wave action. He painstakingly investigated the most suitable paint and firing conditions, putting the wasted tiles to good use later as fragments of constructions. The mural was painted with wide brushes on long handles so that he could reach into the centre of the work. This enabled him to draw great arching curves in a rhythmic progression across a wall and, it seems, back into a deeper space beyond it, where wind and ocean meet.

The mural for Seeger was to be attached to a 32-foot-long beam, nine feet above floor level, in the music room of a new house. Lanyon felt that with a private commission he would be able to resolve the painting as he wished and 'provide both a myth and a sense of continuity for a developing collection': Seeger already owned *Europa, Susan* and *Salome*, all essentially variants on the theme of the body as landscape. He wanted a painting about the sea, so it is not surprising that one of the three, full-size sketches Lanyon presented to Seeger – the one that he eventually selected – was loosely based on *Porthleven*. Lanyon chose to reinterpret the rhythmic imagery of the Liverpool mural, returning to the long, thin format of the works from the late 1940s. Thus the idea of the tall, thin figure in *Porthleven* is transformed into a long strip of

49
Colour Construction
1960
Stained glass and
neon light
64.2 x 62 x 62.8 cm
Arts Council Collection

50 *Above right*
*The Conflict of Man
with the Tides and
Sands* 1960
Mural at Liverpool
University, Civil
Engineering Building
Enamel colour on
porcelain
266.6 x 701.4 cm

51
Mural for Faculty of
Arts Building,
University of
Birmingham 1963
Oil on blockboard
panels
289 x 487 cm (bottom)
609 cm (top)

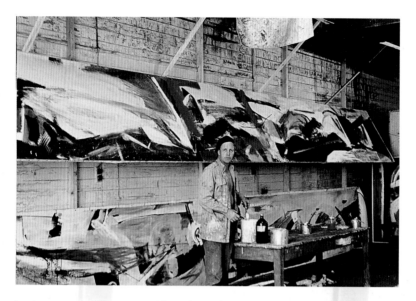

land across which the sea swirls and recedes so that we see now sand and soil, now the deep centre of the ocean.

The third, Birmingham mural is in a glass-walled entrance hall. Again, it is concerned with water, wind and landscape, expressed through great leaping curves. No preconditions seem to have been laid down for this painting, though Lanyon substantially altered his original scheme for the colour because he was dissatisfied with its relationship to the actual landscape visible through the glass walls.

Though these were the first murals that he had made since the war, in the early 1950s Lanyon had made a group of large, freely painted gouaches which suggests that at the time of *Porthleven* he was thinking on a mural scale. One, undated, is a transformative study of the anatomy of a human leg, which is faintly echoed in a painting called *Corsham* of a tall figure with echoes of landscape.

Prior to painting the Birmingham mural, Lanyon spent eight weeks early in 1963 as Visiting Painter at the San Antonio Art Institute in Texas. *Eagle Pass* (fig.53) contains the memory of a trip that he made to Mexico at this time. We see the pass as if from inside a car, though a wheel is also visible and the vehicle appears to be flying. Its vivid colour and precise details indicate, as Andrew Causey has suggested, that Lanyon was increasingly planning much of the composition before embarking on it, so that there are fewer layers of paint to conceal one another and allow glimpses back to earlier versions. *Eagle Pass* exists entirely in the present, depicting a fleeting moment that parallels the action painter's encounter with the canvas, though its pre-conceived, anecdotal nature separates it decisively from action painting proper.

The southern part of the United States provided a revelation to match that of Italy a decade earlier. Immersed in a landscape as vast as that of southern Africa, Lanyon responded to its hard, clear light, its scale and brilliant colour, and to the lives of the people who lived there, with their markets, houses and animals. So attracted was he to the exuberance and openness of American society that he spent a good deal of time trying to arrange a long-term teaching post in the United States. Two further groups of paintings, made in

52
Lanyon with two sketches (*Porthmeor* above and *Porthleven* below) for Seeger mural 1962

53
Eagle Pass 1963
Oil on canvas
121.9 x 91.4 cm
Private Collection

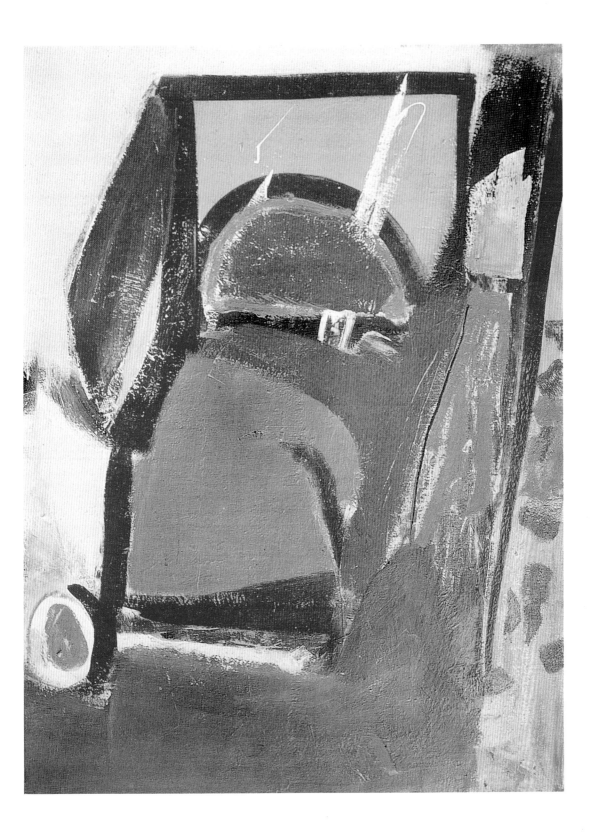

1964, reveal the impact of his recent experience of the art and environment of America.

In February 1964 Lanyon was invited to lecture in Czechoslovakia in connection with a British Council exhibition called *British Painting 1900–1962*. It was a packed fourteen days, during which he moved between Prague and Bratislava, met artists, students, members of the Painters' Union, visited museums and made a trip into the High Tatras in northern Slovakia. Accompanied by an interpreter, he intended to reach an observatory, though it proved to be inaccessible because of snow. Later, he painted a memory of the expedition in *Untitled (Observatory)* (fig.54). The dome of the building is visible in a rock-strewn landscape on the left, while the central section suggests a high blue sky. On the right a shadowy figure confronts the snow, which is presented like an impassable edge.

Lanyon was impressed by contemporary Czech art, which sought to follow western idioms rather than Soviet-style academicism. He immediately recognised its cultural and ideological significance in the repressive political context of the time. A visit to an official Socialist Realist artist ('we practised diplomatic rudeness and mutually loathed each other'[11]) underlined the problems faced by independent artists. Museum directors proudly showed him abstract and constructive pieces only recently admitted to public view. Though wary of pure abstraction, Lanyon acknowledged its cultural importance and

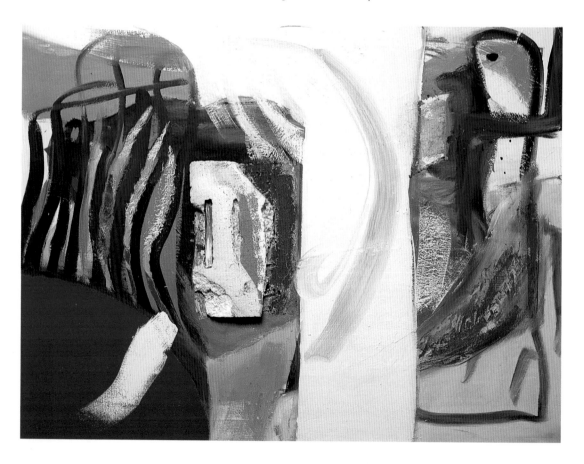

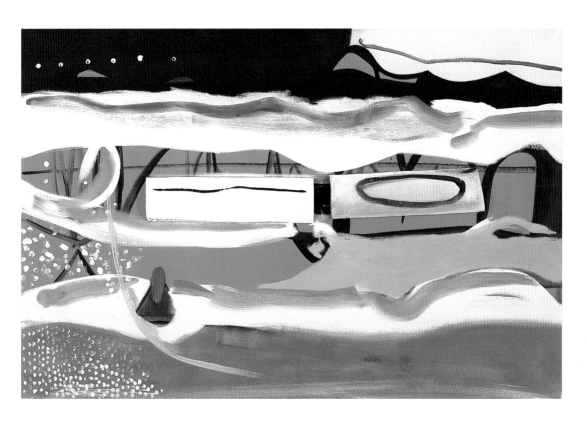

54
Untitled (Observatory)
1964
Oil on canvas
91.4 x 121.9 cm
Private Collection

55
Clevedon Night 1964
Oil and polystyrene on
canvas
122 x 182.8 cm
Private Collection

presciently envisaged the development of a central European modern art, very different from western modernism, which would draw on Gothic and local traditions.

He prepared meticulously for his two lectures on modern English painters and English landscape painting. Full of enthusiasm and vitality, they also contained important explanations of his own work. He spoke of his belief that landscape was the core of British painting and of his affinity with the United States, 'where I have found artists more closely resembling myself', even though many Americans considered landscape painting to be a restricted, 'provincial activity'.[12]

Lanyon felt that landscape painting had been transformed by Cézanne and the Constructivists, who had defined space itself as the subject of a work of art. After showing a slide of Gabo's *Construction in Space: Spiral Theme* (fig.13), he concluded that

> The real place of the painter today in a landscape tradition is in the creation of works which transform the environment and fill people with images to understand the immense range of human curiosity particularly in the sciences. Landscape then is not any longer tied specifically to 'nature' as the country, but infuses a painting with a sense of the forces beyond human scale.[13]

We are reminded of the Liverpool and Seeger murals, which refer to natural forces both harnessed and unrestrained, as well as Lanyon's long tutelage to Gabo, for whom art added a mythic dimension to human scale. In the lecture, Lanyon reasserted his perception of landscape as an infinitely diverse

component of the environment, aligned with the frailties of human life and history.

During the summer of 1964, Lanyon took a group of students from the West of England College of Art in Bristol to paint on the nearby coast at Clevedon. The expedition precipitated a group of paintings radically different from any that he had previously made in England, though they can be seen as a development of his work in San Antonio. In *Clevedon Night* (fig.55) we see lights on the pier, dark sky, water and a pink, nude body. The image is set below two strips of polystyrene, collaged horizontally to the canvas, strong static accents that are counterparts to the fluidity of the water. Their introduction into what is essentially a painting of the sea serves to bridge the gap between oil painting and smaller pictorial constructions like *Turn Around* (fig.48), genres that Lanyon had previously kept rigorously apart. No doubt he was aware of the assemblages of Jasper Johns and Robert Rauschenberg, in which three-dimensional objects were attached to the canvas, and he was certainly familiar with the work of Pop artists like Peter Blake and Joe Tilson. However, these were city-oriented artists, whereas the painting-constructions that Lanyon made at Clevedon were, of course, based on a rural landscape.

With *Glide Path* (fig.56) Lanyon addressed an old theme in a new idiom: clear, almost cut-out forms in brilliant red and green are crossed by two lines of black plastic that indicate the path of the glider. They are direct and unequivocal, imparting a greater sense of speed over the land than any of the previous gliding paintings. We may also see them as a metaphor for the artist's sense of purpose and determination to cut through problems in pursuit of an aesthetic goal. Some months earlier, Lanyon had used similar colours in a construction that recalls Anthony Caro's larger sculptures in painted steel. Entitled *Field Landing* (fig.57), it relies for its impact on the impossibility of

56
Glide Path 1964
Oil and plastic on canvas
170.4 x 136.3 cm
The Whitworth Art Gallery,
University of Manchester

57
Field Landing 1963–4
Painted wood, plastic,
perspex and metal
93 x 153.3 x 53.9 cm
Private Collection

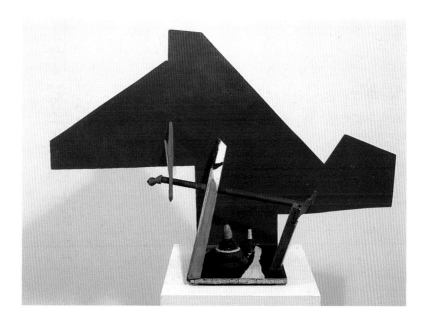

seeing both sides of the piece simultaneously. The title refers to the hazards of an unplanned landing: with one side green and the other red, the safe field and the danger zone are brought together as *alter egos*. The shape of the metal, it has been remarked, resembles that of a schematic horse's head, in a poignant return to myths of life and death within the landscape.

Throughout the summer of 1964 Lanyon went gliding on every possible occasion. One day in August, on a training course with the Devon and Somerset Gliding Club, he came in to land too low; the glider nose-dived and catapulted him out. He died four days later as a result of his injuries. Lanyon is buried on the edge of the sea in Lelant churchyard, where his grave slab carries an inscription from one of his own poems:

I will ride now
The barren kingdoms
In my history
And in my eye.

A Critical Reputation

'What is certain is that [Lanyon] is one of the few English painters today and certainly the first Cornish one to gain an international reputation.' Thus John Dalton wrote in *The Studio* in 1962,[1] in acute contrast to Robert Melville's bemused comments eight years earlier. Throughout his lifetime, Lanyon's reputation rose steadily as critics gradually became more at ease with a body of work that defied all the conventions of landscape painting.

The start of his professional career coincided with a time when landscape painting was seen as the pinnacle of British aesthetic achievement, a glorious historical phenomenon that no modern artist could hope to emulate. Yet Turner, a central figure in this tradition, whose example was so important for Lanyon's paintings of weather, had provided an exemplary model for the modernisation of landscape art. In paintings like *Rain, Steam and Speed* (exh.1844; National Gallery, London) Turner had 'developed a style of painting [more] adequate to articulate the power of steam, its power to transform notions of time and space as well as physical matter'.[2]

As we have seen, Lanyon's approach, announced with the first Crypt Group exhibition, was that of a pioneer intent on developing a new visual language. Not content with a local, Cornish dialect, he set out to create a language of painting that would encourage a reassessment of the nature of landscape. For Lanyon, this was a fluid and inclusive term, which incorporated the historical and the modern; wild, rocky capes and sunny beaches; empty moors and seaside towns; the perspective of the walker and the cyclist as well as that of the glider pilot. To paint a phenomenon of such complexity, in which time is telescoped and different kinds of subject constantly overlap, so that a landscape and a woman's body may be interchangeable, clearly required an approach as revolutionary as Turner's had been a century earlier.

In order to refer convincingly to the modernity of landscape, Lanyon needed to develop a correspondingly modern language of painting that would be recognised beyond the boundaries of his own province. The dialectic between the local and the international is a thread that runs throughout his career. As he emphasised in his British Council lectures in 1964, neither category was exclusive. Though he was rooted in Cornwall, with an intense awareness of its history and culture, he had recognised his need for the stimulus of the unknown on his first visits abroad in the late 1930s. Familiarity with ancient places and customs, especially in Italy, enabled him to look afresh at Cornwall and to reinterpret it. Similarly, contact with other artists, from Borlase Smart to de Kooning, helped him to develop a language of paint that evolved constantly throughout his career.

Lanyon was very clear that critical and financial success depended on exhibiting his work in London and other international centres. 'St Ives', he remarked, 'is a workshop and not a showplace'.[3] For a showplace he was indebted to his supportive dealers, Gimpel Fils, who helped him through lean times, facilitated and then accommodated his often difficult relationship with the Catherine Viviano Gallery in New York and still show his work.

Like many of his contemporaries, Lanyon benefited from the British Council's exhibiting programme, which brought young artists to the notice of foreign critics and dealers. The process by which his work moved from a local to an international arena was in part simply a practical matter of exhibiting opportunities offered by the British Council. Group exhibitions provided the chance, to which Lanyon responded enthusiastically, for work to be seen and assessed in many different contexts. Even at the beginning of his career these ranged from the Newlyn Gallery to the constructivist-oriented Salon des Réalités Nouvelles in Paris, where he showed in 1947 and 1949, invited initially by the French painter Jean Herbin. In 1950 he took part in the Institute of Contemporary Arts show *London–Paris* as a representative of current innovative painting, alongside Hans Hartung, Francis Bacon and Lucian Freud; the following year he was in Gimpel Fils' renowned *British Abstract Art*, an authoritative assemblage of advanced art. In 1953 his work was to be seen in the biennial International Watercolour Exhibition at the Brooklyn Museum, New York, in a mixed exhibition at a New York commercial gallery and in the Arts Council's touring show, *West Country Painting*. *St Just* made its first public appearance that summer, in Patrick Heron's *Space in Colour*, at the Hanover Gallery, London, a landmark exhibition that explored the persistence of the subject in apparently abstract painting.

Later, in 1957, when he was becoming recognised as an important contemporary painter rather than simply a promising young artist, Lanyon was invited to show in *Dimensions*, a seminal survey exhibition at the O'Hana Gallery in London. It was arranged by Lawrence Alloway, who worked indefatigably to establish contemporary British art on equal terms with that of Paris and New York. Alloway put Lanyon in a category of painterly artists, whose 'highly abstracted pictures contain allusions to landscape, still life, or figure'.[4] A year later Lanyon showed six recent paintings in *Metavisual, Tachiste, Abstract*, at the Redfern Gallery, London, a gathering of painters 'eager to press ahead into little-chartered [sic] territories'.[5] Its purpose was to explore the relationship between British artists and 'Action painting – the hybrid style of the Frenchman Dubuffet, the German Ernst, the American Jackson Pollock … an international style'.[6]

Though Lanyon was scarcely affiliated to 'an international style', his participation in such events served to confirm his position as a pioneer in the mould of those who, like Gabo, had reformulated art for their times. His work was in steady demand for British Council exhibitions, from the Pittsburgh International at the Carnegie Institute in 1955, to the Soviet Union, where he contributed to *British Painting 1700–1960*. However, the type of exhibition in which he was invited to take part changed as his career developed. Whereas his participation in *Six Painters from Cornwall*, which toured Canada in 1955–6, located him firmly within a British regional school, his inclusion in 1959 in the second Dokumenta at Kassel suggested that his critical status had changed by this time. In 1959, Dokumenta was well

on the way to its present status as the most prestigious of all international exhibitions, the most rigorously selected and the one at which the newest of advanced art is displayed. In 1962 Lanyon won a Selection Prize in the Premio Marzotto on the first occasion on which it was open to non-Italian artists. His winning painting was *Orpheus* (1961; Premio Marzotto Institution, Valdagno), a character whom he compared with 'the artist searching for his image, for the meaning of what he is doing',[7] a comment that was surely only partly ironic, for he continually invented new ways of making images.

A critical reputation is more difficult to assess than an exhibiting career, while it is also much more significant in the long term. Early in 1954, Lanyon was awarded the recently established Critics' Prize by the International Association of Art Critics, for *Mullion Bay* (fig.37). The remit of the selection committee was to choose a young painter who was 'on the verge of success but had yet fully to achieve it … whose work showed promise of further development'.[8] The citation read 'Lanyon's painting is near-abstract but contains, especially in its colour, many echoes of Cornish landscape'. Often at a loss for words to express their response to his painting, critics seized on its colour and romantic quality, writing of 'near-abstract essays in grey and green-yellow … recognisably Cornish'[9] or 'intensely romantic abstractions'.[10] An unjustified tendency to categorise all art produced in Cornwall as romantic persists to this day, as does the emphasis on the realism of Lanyon's colour at the expense of other aspects of his work.

His paintings are certainly difficult, sometimes impossible to decipher; to read reviews of his early exhibitions is to sympathise with critics who recognised their quality but were unable to explain why. Few were as honest as John Berger, who admitted 'Peter Lanyon remains, as far as I am concerned, a mystery'.[11] Only Patrick Heron, reviewing Lanyon's second exhibition at Gimpel Fils, had both the insight and the vocabulary to explain why his friend had 'the capacity to revolutionise the art of landscape painting'.[12] A few years earlier, in 1951, when Lanyon had been one of a group of artists from Cornwall who showed at Heal's Mansard Gallery, London, another writer made the point that 'Lanyon is not an easy painter to assess. His paintings have a suppressed fury which suggests the workings of dark metaphysical forces, and consequently impress without always pleasing'.[13] We are reminded by this of paintings like *Isis (Finding a Limb of her Slaughtered Son)* (1949; private collection), which shows a human figure, crouched and compressed, apparently underground. Today, reviewing the whole of Lanyon's oeuvre, we can relate *Isis* and paintings like it to his recurrent use of subterranean imagery as a metaphor for death. Inevitably, some of Lanyon's paintings will continue to baffle us and in other cases we may offer readings that he did not himself propose or even envisage.

The first opportunity to compare a body of Lanyon's work with that of his foreign contemporaries came with his solo exhibition in New York in 1957. A phase of his career had ended the previous year, aptly symbolised by the family's move to Little Park Owles. Within a period of eighteen months, Lanyon had opened his own art school and ceased to teach at Corsham. The invitation to show with Catherine Viviano came at an opportune moment. It encouraged him to continue to develop the kind of painting seen in *Silent Coast* and *High Ground*, which was inflected by an American and international idiom.

The 1957 show was trailed by a substantial article in *Arts (New York)* by

Heron, who was then the magazine's London correspondent. Heron's concluding sentence issued a challenge to critics in New York, stating that Lanyon's 'quality entitles him to more than a local reputation on this side of the Atlantic'.[14] Much reproduced in the years since it was originally published, this perceptive article was the most substantial that had been written about Lanyon and the first to attempt to explain his working process in any detail.

Heron was also the first critic to identify St Ives painting – produced by such artists as Terry Frost, Roger Hilton, Bryan Wynter, Heron himself and, of course, Lanyon – as a phenomenon worthy of international attention. He proselytised energetically on behalf of his colleagues, successfully stimulating interest in their work in New York. However, the wave of curiosity that enabled Lanyon and his colleagues to enter the American art market was not strong enough in the long term to sustain interest in their work in competition with new media and new art forms later in the 1960s.

Like his contemporaries, Lanyon welcomed the opportunity to show and sell in New York. He responded with delight in 1963 to the landscape of Texas, where he evolved a simpler, more direct way of painting. During the 1960s, new patrons, commissions and his dealers' demands for ever greater numbers of paintings placed him under pressure of a kind that he had not previously experienced. However, he was by now well equipped to deal with it though occasionally, painting in haste to prepare for an exhibition, he succumbed to clichés, such as the concentric lines of a neatly dragged circle of paint. Despite the pressure to increase his exposure abroad, Lanyon remained firmly rooted in Cornwall. In 1961, when he showed at the São Paulo Bienal, he was a visiting lecturer at both Falmouth College of Arts and the West of England College of Art in Bristol. He also became chairman of the Newlyn Society of Artists, to which he remained intensely loyal.

58
Peter Lanyon, 1964

The dialectic between the local and the international was fundamental and inspirational. At home, Lanyon was a senior artist, sought out for advice and encouragement by students and young painters, many of whom recall his generosity and willingness to spend long hours discussing their work. At the same time, he was, it seems, aware of the danger of restricting himself to a local milieu and local fame. He was too energetic, ambitious and intellectually questing not to have confronted the challenge posed by his contemporaries beyond the confines of Cornwall.

In 1960, when Lanyon made his first gliding paintings, he was still in his early forties, well-known in the art world, respected and acclaimed by the limited number of critics who understood his work. He had, one of them concluded, 'decisively broken with the parochialism that still dominates artists, critics and public in England'.[15] Comparisons with American painting enhanced his reputation, while his rich overlays of colour and sweeping brushmarks made his work more evidently pleasing than it had been in 1951 at the time of the Mansard Gallery exhibition.

Undoubtedly there were disappointments: he never showed at the Venice Biennale, nor did a projected retrospective exhibition at the Whitechapel Art Gallery in London come to fruition. When he was invited to exhibit at São Paulo in 1961, with William Scott, Merlyn Evans and the sculptor Lynn Chadwick, it was Scott who won the Shell Acquisition Prize. He had already beaten Lanyon to first place two years earlier, in the British Painters' section of the John Moore's exhibition.

Today their relative positions are reversed: Lanyon is seen to have had a greater emotional and thematic range and to have made more visually beguiling paintings. The difficulties that he experienced in making his work understood were products of its intellectual complexity and the eager assimilation of the new that led it to be so often aligned with Action Painting. Lanyon made paintings that appeared to be abstract and therefore incomprehensible, at a time when abstraction was viewed with extreme suspicion, often mocked and considered to be meaningless. While his dealers begged for gouaches which, unlike the awkwardly large oils, they could sell readily, Lanyon defiantly wrote 'I certainly have no intention of selling work in a market which is geared to paintings often produced in two hours instead of two years … I realise that my painting is not in demand and it is a waste of time living in a fool's paradise about this'.[16]

Despite eager collectors who bought his work in the United States, the situation remained difficult at home: in March 1964 Peter Gimpel was still obliged to admit that 'the only thing I have been able to sell recently have been your gouaches'.[17] Lanyon was not helped by the position of landscape painting in relation to advanced art in the late 1950s and early 1960s, when the cutting edge was very clearly located in London, rather than in a rural context. When Pop Art was about to make its spectacular debut in London, the New Generation was gathering, and American hard-edge was starting to displace Abstract Expressionism. Landscape painting, still resolutely tagged romantic, appeared old-fashioned and evasive of current issues. The situation intensified when kinetic art, multi-media work, Happenings and the first installations became the favoured media for experimental artists in the 1960s. When Lanyon died, he was recognised by a small number of discerning critics and collectors as an extremely significant and innovatory artist, yet he was planning to teach in Australia early in 1965 before travelling on to the United States for an interview for another teaching post because he was still unable to live from sales of his work.

Lanyon's first retrospective, with over seventy paintings and many constructions, the exhibition that should have taken place at the Whitechapel Art Gallery, was arranged by the Arts Council and first shown at the Tate in 1968, four years after his death. It received some sympathetic reviews but had little lasting impact. 1971 saw the publication of a monograph by Andrew Causey, who also arranged an exhibition of paintings, drawings and constructions, with the Seeger mural, at Manchester University's Whitworth Art Gallery in 1978. Its detailed, probing catalogue remains a milestone in publications on Lanyon. Causey was the first writer to address the paradoxes of Lanyon's paintings and the difficulty of comprehending them. The drawings received more detailed attention three years later when Haydn Griffiths, who had previously made a study of Corsham during the period when Lanyon taught there, organised a travelling exhibition of nearly a hundred works on paper.

None of these initiatives succeeded in banishing the prevalent perception of Lanyon as a difficult artist, one who belonged essentially to the early post-war years and was therefore out of place among the conceptual art that dominated the 1970s. Yet in a review of an exhibition at the New Art Centre in 1975, the critic William Feaver wrote 'Not only is his idiom respectable once more, his standing also, as a pioneer in fields seemingly

dominated by Americans over the past twenty years, is increasingly recognised'.[18] Though Feaver's prediction of a revival was premature, the importance and originality of Lanyon's work was appreciated and acknowledged by art historians well before it began to sell readily. Today it brings high prices at auction and there is hardly a week during which it is not possible to see at least one painting by Lanyon in a West End gallery.

Since the early 1990s several academic theses have probed Lanyon's work and some of his extraordinarily vivid and informative letters have been published. His son, Andrew, has published much previously unknown writing by and on his father some, like texts from broadcasts, articles and lectures serious, and some delightfully ephemeral. He has provided much detailed information on his father's life, as well as recording little-known works of art. All this material has contributed to our recognition of the plurality of Lanyon's practice, in which painting, teaching, gliding and beach-combing were separate but interlinked activities that constantly informed one another.

Recent attention has focused on less familiar aspects of Lanyon's production. The constructions, for so long accepted on his own terms as no more than painting aids, were first exhibited as fully-fledged works of art by Gimpel Fils in 1975. This was followed by a larger South Bank touring show in 1992, which set constructions beside the relevant paintings and put many previously unknown pieces on public view. In 1996 Gimpel Fils showed some of the many mural sketches, including those for Liverpool and Birmingham, for the first time. Valuable though these exhibitions were, much remains to be rediscovered: Lanyon's prints, pots and collages, for instance, are still virtually unknown territory.

It is no coincidence that a reassessment of Lanyon's work has taken place within the fluidity of postmodernism. Just as Europe has once again become an open territory, released from old boundaries, so have historians discarded their narrow classifications of artists by nation, school or subject matter. The destabilisation of rigid categories means that we may see Lanyon as both Cornish and international; as a painter of landscape and the body; as an artist who worked consciously within the historical landscape tradition and contributed greatly to its revitalisation even while he announced his affinity with contemporary American painting.

It is no longer enough to study complex artists through the single lens of art history: we need to investigate them from the vantage points of different disciplines. It is in this respect fortunate that geographers have begun to study Lanyon's work in relation to their own sophisticated, if far from unanimous theories of landscape and place. While a good deal of cross-disciplinary work of this kind has been done on eighteenth- and nineteenth-century painting, the difficult relationship between place and seemingly abstract painting has been ignored until now.

All artists' reputations fluctuate, but more than thirty years after his death, Lanyon's position has become secure. Not only is his work esteemed by collectors, both private and public, but it is the subject of serious scholarly research, which promises to extend greatly our understanding of artists' representation of landscape. Yet we should not forget that it was Lanyon himself who initiated this research, with his incessant quest for the apposite image and his desire to extend the boundaries of landscape painting. I have tried to demonstrate his success in this enterprise and to

explain why some now esteem him as the most innovative British landscape painter since the Second World War. Much remains to be learnt about his work and, as we investigate it more closely, it will in turn teach us much about the places that he painted and the way that they were formed and continue to develop.

Nothing, in Lanyon's life or his art, stood still; living and painting combined in a constant process of discovery, invention and participation. We may leave him with his own words, an acclamation of the power and centrality of painting: 'Painting is a source and not an echo, it is active and not passive, looking forward and assisting in a positive, constructive view of the world.'[19]

59
Lanyon grinding
pigment, 1954

Notes

TGA = Tate Gallery Archive

Unless otherwise stated, all unpublished material is in the collection of Sheila Lanyon

CHAPTER 1

1 Peter Lanyon, 'A Sense of Place', *Painter and Sculptor*, no.5, Autumn 1962, pp.3–7.

2 'An Illustrated Slide Lecture on English Landscape', typescript, 1964.

3 Ibid.

4 Ibid.

5 Peter Lanyon, 'Abstractions and Constructions', 1959, TGA/TAV 213 AB.

6 Robert Melville, 'Exhibitions', *The Architectural Review*, June 1954, pp.414–15.

7 'Peter Lanyon and Paul Feiler Talking to Michael Canney on "The Subject in Painting"', *Horizons*, BBC radio programme, 22 May 1963, TGA/TAV 212 AB.

8 Recorded talk for the British Council 1963, in Andrew Lanyon, *Peter Lanyon 1918–64*, Penzance 1990, p.180.

9 Ibid.

10 Ibid., p.172.

11 Typescript, 28 March 1962, in Lanyon 1990, p.285.

12 Letter to Naum Gabo, Feb. 1949, in Margaret Garlake, 'The Letters of Peter Lanyon to Naum Gabo', *The Burlington Magazine*, 1995, pp.233–41.

13 John Berger, 'Peter Lanyon, at Gimpel Fils', *The New Statesman and Nation*, 15 March 1952, p.303.

14 Undated text, in Lanyon 1990, p.290.

15 Tim Ingold, 'The Temporality of the Landscape', *World Archaeology*, Oct. 1993, pp.152–74.

16 'Peter Lanyon, Alan Davie and William Scott Talking to David Sylvester of the BBC about their Work', 19 June 1959, TGA/TAV 214 AB.

17 C. Marriott, 'Memories of Cornwall's Art Colonies', *The Cornish Review*, Spring 1950, pp.66–71.

18 Lanyon 1990, p.27.

19 Ibid.

20 Ibid.

21 Ibid.

22 Ibid., p.28.

23 Ibid., p.49.

24 Letter to Naum and Miriam Gabo, undated but early 1940.

25 Letter to Naum Gabo, 9 May 1948, in Garlake 1995.

26 Letter to Ben Nicholson and Barbara Hepworth, 27 June 1941, in Andrew Lanyon, *Wartime Abstracts: The Paintings of Peter Lanyon*, Penzance 1996, p.34.

27 Herbert Read, 'Vulgarity and Impotence', *Horizon*, April 1942, pp.267–76.

28 Letter to Nicholson and Hepworth, 2 May 1942, in Lanyon 1996, p.47.

29 Letter to Naum and Miriam Gabo, 3 Dec. 1944, in Garlake 1995.

30 Letter from Richard Hoggart to the author, 2 Sept. 1993.

31 Letter to Mary Schofield, 23 July 1944, in Lanyon 1996, p.70.

32 Letter to Mary Schofield, 4 April 1945, in ibid., p.77.

CHAPTER 2

1 Lanyon 1990, p.72.

2 Letter to Naum Gabo, Feb. 1949, in Garlake 1995.

3 Ibid.

4 Ibid.

5 Victor Pasmore, 'Abstract Painting in England', letter to *The Listener*, 13 Sept. 1951, p.427.

6 Letter to Naum Gabo, 30 May 1947, in Garlake 1995.

7 Letter to Naum Gabo, 9 May 1948, ibid.

8 Letter to Naum Gabo, 30 May 1947, ibid.

9 Letter to Naum Gabo, Feb. 1949, ibid.

10 'The Face of Penwith', *The Cornish Review*, Spring 1950, pp.42–4.

11 Recorded talk for the British Council, 1963, in Lanyon 1990, p.90.

12 Michael Middleton, 'Art', *The Spectator*, 21 Oct. 1949, p.534.

13 Patrick Heron, 'Adrian Ryan and Peter Lanyon', *The New Statesman and Nation*, 15 Oct. 1949, pp.422–3.

14 David Lewis, 'Peter Lanyon', *The Cornish Review*, Spring 1950, pp.72–3.

15 Michael Canney, letter to the author, 7 Nov. 1996.

16 *Horizons*, op. cit., in Lanyon 1990, p.242.

17 Recorded talk for the British Council, 1963, in Andrew Lanyon, *Portreath: The Paintings of Peter Lanyon*, Penzance 1993, p.8.

18 In Hadyn Griffiths, 'Introduction', in *Peter Lanyon: Drawings and Graphic Work*, exh. cat., City Museum and Art Gallery, Stoke-on-Trent 1981, unpaginated.

19 'Time, Space and the Creative Arts', ms. notes, 31 Dec. 1948.

20 Lanyon 1990, p.124.

21 Ibid., p.125.

22 Ibid.

23 Letter to Ivon Hitchens, undated but late 1952, in Margaret Garlake, 'The Constructions of Peter Lanyon', in *Peter Lanyon: Air, Land and Sea*, exh. cat., South Bank Centre, London 1992, pp.49–61.

24 Recorded talk for the British Council, 1963, in Lanyon 1990, p.121.

25 Ibid., in Andrew Causey, *Peter Lanyon*, Henley-on-Thames 1971, p.19.

26 Ibid.

27 Letter to Peter Gimpel, c.1954.

28 'Peter Lanyon's Glimpse of Glory', *The Scotsman*, 27 March 1954.

29 Tony Matthews, letter to the author, 10 Jan. 1997.

30 Jeremy le Grice, telephone conversation, Nov. 1996.

31 Nancy Wynne-Jones, in Lanyon 1990, pp.325–7.

32 Jeremy le Grice, telephone conversation, Nov. 1996.

33 Lanyon 1990, p.190.

34 Tate Gallery Conservation Department report on T03693.

35 Ibid.

CHAPTER 3

1 Lanyon 1962, pp.3–7.

2 Lanyon 1990, p.156.

3 Ibid.

4 Recorded talk for the British Council, 1963, ibid.

5 Lanyon 1990, p.158.

6 Letter to Naum Gabo, Feb. 1949 in Garlake 1995.

7 Lanyon 1990, p.166.

8 Peter Lanyon, 'Offshore in Progress', *Artscribe*, no.34, 1982, pp.58–61.

9 Causey 1971, p.27.

10 David Thompson, 'Introduction', *New Generation 1964*, exh. cat., Whitechapel Art Gallery, London 1964, pp.7–8.

11 Report on visit to Czechoslovakia, typescript, 1964.

12 'Some Aspects of Modern British Painting: An Artist's Point of View', lecture, typescript 1964.

13 Ibid.

CHAPTER 4

1 John Dalton, 'Lanyon and Landscape', *The Studio*, 1962, pp.178–81.

2 Stephen Daniels, 'Human Geography and the Art of David Cox', *Landscape Research*, vol.9, 1984, pp.14–19.

3 Letter to *The St Ives Times*, 3 July 1953.

4 *Dimensions: British Abstract Art 1948–1957*, exh. cat., O'Hana Gallery, London 1957, unpaginated.

5 Denys Sutton, 'Preface', *Metavisual, Tachiste, Abstract*, exh. cat., Redfern Gallery, London 1957, unpaginated.

6 Ibid.

7 Lanyon 1990, p.209.

8 *Art News & Review*, vol.6, 20 Feb. 1954, p.5.

9 'London–Paris', *Sunday Times*, 12 March 1950.

10 Michael Middleton, 'Round the Galleries', *The Spectator*, 7 March 1952, p.293.

11 John Berger, 'The Face of Nature', *The New Statesman and Nation*, 28 Jan. 1956, p.97.

12 Patrick Heron, 'Peter Lanyon', *Art News & Review*, vol.6, 6 March 1954, p.7.

13 M. Williams, 'Drama and Art Notes', *The Cornish Review*, Spring 1951, pp.69–72.

14 Patrick Heron, 'Peter Lanyon', *Arts* (New York), Feb. 1956, pp.33–7.

15 Alan Bowness, 'Middle Generation', *Art News & Review*, vol.11, 9 May 1959, pp.6–7.

16 Letter to Peter Gimpel, 18 May 1955 in Lanyon 1990, p.152.

17 Letter from Peter Gimpel, 5 March 1964.

18 William Feaver, *Financial Times*, 21 Jan. 1975, in Lanyon 1990, pp.321–2.

19 Peter Lanyon, notes, 30 Sept. 1963, in Lanyon 1990, p.245.

Credits

The publishers are grateful to Sheila Lanyon and Andrew Lanyon for their kind assistance in obtaining illustrations.

Numbers refer to figure references.

Albright-Knox Art Gallery, Buffalo, New York 17, 40
Arts Council Collection 43
Studio St Ives frontispiece
Bernard Jacobson Gallery 5, 6
Birmingham Museums and Art Gallery 42
University of Birmingham 51
The British Council 31
Christie's Images 38
A.C. Cooper 49
Gimpel Fils 44, 47, 55
Hirshhorn Museum and Sculpture Garden, Smithsonian Institution 2
Andrew Lanyon 58
University of Liverpool 50
Manchester City Art Galleries 39
National Gallery of Victoria, Melbourne 37
The Pier Gallery Collection, Stromness, Orkney 11
City Museums and Art Gallery, Plymouth 33
Private Collections 7–9, 22, 35
Sotheby's Picture Library 35
Stanley Seeger 20, 34
Tate Gallery Archive. Photo presented by Sheila Lanyon 25
Tate Gallery Photographic Department 1, 10, 12–14, 16, 19, 21, 23, 24, 26, 27, 29, 30, 32, 41, 45, 46, 48, 52, 54
The Whitworth Art Gallery, University of Manchester 56

Select Bibliography

ARTS COUNCIL: *Peter Lanyon*, exh. cat., London 1968.

CAUSEY, Andrew, *Peter Lanyon*, Henley-on-Thames 1971.

CAUSEY, Andrew, *Peter Lanyon*, Bernard Jacobson Gallery, London 1991.

CROSS, Tom, *Painting the Warmth of the Sun: St Ives Artists 1939-1975*, Penzance and Guildford 1984.

DALTON, John, 'Lanyon and Landscape', *The Studio*, Nov. 1962, p.178–181.

DAVIES, Peter, *St Ives Revisited: Innovators and Followers*, Abertillery, Gwent, 1994.

ENRIGHT, Mo, *The Mural Studies of Peter Lanyon*, exh. cat., Gimpel Fils, London 1996.

GARLAKE, Margaret, 'The Letters of Peter Lanyon to Naum Gabo', *The Burlington Magazine*, April 1995, pp.233–46.

HERON, Patrick, 'Peter Lanyon', *Arts* (New York), Feb. 1956.

LANYON, Andrew, *Peter Lanyon 1918–64*, Penzance 1990.

LANYON, Andrew, *Portreath: The Paintings of Peter Lanyon*, Penzance 1993.

LANYON, Andrew, *Wartime Abstracts: The Paintings of Peter Lanyon*, Penzance 1996.

LANYON, Peter, 'A Sense of Place', *Painter and Sculptor*, no.5, Autumn 1962, pp.3–7.

LANYON, Peter, 'Offshore in Progress', *Artscribe*, no.34, March 1982, pp.58–61.

'Letters from Peter Lanyon to Roland Bowden', *Modern Painters*, spring 1992.

LONDON: South Bank Centre, *Peter Lanyon: Air, Land and Sea*, exh. cat. 1992.

LONDON: Tate Gallery, *St Ives 1939–64: Twenty-five Years of Painting, Sculpture and Pottery*, exh. cat. 1985.

MANCHESTER: Whitworth Art Gallery, *Peter Lanyon, Paintings, Drawings and Constructions 1937-64*, exh. cat., 1978.

STOKE-ON-TRENT: City Museum and Art Gallery, *Peter Lanyon, Drawings and Graphic Work*, exh. cat., 1981.

Index

A

Abstract Expressionism 46, 47, 50, 72
abstraction and representation 7, 26
Abstract Study, Italy 22, 26; fig.16
Action Painting 72
Africa 14–15, 19–20
Alloway, Lawrence 68
Anticoli Corrado 40, 50
Arts Council 34, 57
Ashton, Dore 50

B

Bacon, Francis 25, 68
Baker, Richard 50
Bath Academy of Art, Corsham 37–8, 43, 44, 69, 72
Bauhaus 19
Beach Girl 42; fig.35
Berger, John 10, 69
Berlin, Sven 29, 30
Birmingham University mural 58, 73; fig.51
Blake, Peter 65
Blue Glass Airscape 56, 58; fig.47
Blue Horse Truant 21, 22, 29; fig.15
Bojewyan Farms 38, 40; fig.31
Bosigran 14
Box Construction No.1 17–18; fig.11
Brancusi, Constantin 18
Brindisi 20

C

Canney, Michael 34
Caro, Anthony 65
Causey, Andrew 26, 29, 42, 60, 72
Cézanne, Paul 63
Chadwick, Lynn 70
Chagall, Marc 19

Christian imagery 39, 40
Circle, International Survey of Constructive Art 16
Clevedon 7, 65
Clevedon Night 65; fig.55
Clifton College 14
Cloud Base 53
Coast Soaring 56; fig.45
Coldstream, William 15
collages 73
Colour Construction 57–8; fig.49
Conflict of Man with Tides and Sands, The 58, 63, 73; fig.50
Constable, John 7
Construction 30; fig.26
Construction in Green 26, 29
constructions 6, 17–19, 36–7, 39, 40, 42, 56–8, 73; figs.11, 12, 30, 32, 41, 47, 48, 57
Construction for St Just 39, 56; fig.32
Constructivism 16–19, 29, 30–1, 63
Contemporary Art Society 34
Corsham 37–8
Corsham Summer 11; fig.6
Corsham Towers 40
critical reception 7, 32, 44, 67–70, 72–3
Cross Country 53; fig.44
Crypt Group 29–31, 34, 67; fig.25
Czechoslovakia 62–3

D

Dalton, John 67
Davie, Alan 49
de Kooning, Willem 46, 50, 67
Easter Monday 50
Drawing in Oval, Agir, Palestine 19–20; fig.14
drawings 9, 29, 50–1, 72; figs.14, 24
Dubuffet, Jean 43, 68

E

Eagle Pass 60; fig.53
Earth 26; fig.22
Ernst, Max 68
Europa 40, 41–2, 51, 58; fig.34
Euston Road School 15
Evans, Merlyn 70
exhibitions 68–70, 72–3
 1938 first one-person, Johannesburg 15
 1942 *New Movements in Art*, London 18–19
 1946-48 Crypt Group, St Ives 29–30, 67; fig.25
 1947 Downing's Bookshop, St Ives 25
 1949 Lefevre Gallery, London 32, 34
 1951 *60 Paintings for '51* 34
 1952 Gimpel Fils, London 38
 1954 Gimpel Fils, London 44, 69
 1956 *Modern Art in the United States*, London 46
 1957 Catherine Viviano Gallery, New York 49–50, 69–70
 1959 Catherine Viviano Gallery, New York 50
 1959 John Moore's, Liverpool 57
 1960 *Modern Stained Glass* 57–8
 1964 *British Painting 1900-1962*, Czechoslovakia 62–3
 1968 retrospective, Tate Gallery 72

F

'The Face of Penwith' 31–2
Feaver, William 72–3
Feininger, Lyonel 19
Festival of Britain 34
Field Landing 65–6; fig.57
figures in Lanyon's work 11, 22, 36, 38, 40, 43, 45, 51
Forge, Andrew 50
Frankenthaler, Helen 50
Freud, Lucian 68
Frost, Terry 70
Fry, Anthony 50
Fry, Maxwell 58
Futurism 19

G

Gabo, Naum 16, 17, 18–19, 20, 22, 29, 30, 31, 32, 68
Construction in Space: Spiral Theme 18, 20, 63; fig.13
Generation 22, 25; fig.19
'Generation series' 6, 22–32
Generator 26; fig.21
Gimpel Fils 38, 68
Gimpel, Peter 43, 72
Glide Path 65; fig.56
gliding and gliding paintings 6–7, 11, 46–7, 52–3, 56, 65–6, 70
Gottlieb, Adolf 50
gouaches 60, 72
Greenberg, Clement 50
Green Buoy 56
Green Mile 40
Griffiths, Haydn 72

H

Hartung, Hans 68
Harvest Festival 40
Hepworth, Barbara 16, 19, 22, 34
Herbin, Jean 68
Heron, Patrick 14, 30, 32, 49, 68, 69, 70
High Ground 46, 69; fig.38
Highlow 50–1
Hilton, Roger 70
Hitchens, Ivon 38–9
Hoggart, Richard 20
Horizon 18, 19

I

Isis (Finding a Limb of her Slaughtered Son) 69
Italy 20–1, 22, 40, 42–3

J

Jackson, Martha 50
James, Philip 34
Johannesburg 15
Johns, Jasper 65

K

Kramer, Hilton 50

L

Landscape with Cup (Annunciation) 25, 26; fig.20
landscapes 6, 7, 9–11, 14, 22–9, 30, 36–7, 40, 42, 43–50, 63, 67, 72
 body, equivalence with 32, 43, 45, 47, 49
Lanyon, Andrew (son) 22, 73
Lanyon, Herbert (father) 11, 14
Lanyon, Lilian (mother) 11
Lanyon, Mary (sister) 11, 14
Lanyon, Peter figs.8, 52, 58, 59
 character 6
 death 7, 66
 engineering skills 18
 psychological crises 15–16, 31, 43, 46
Lanyon, Sheila (wife) 22
Levant Old Mine 43; fig.36
Lewis, David 32
Lissitsky, El 19
Little Park Owles 16, 46, 69

Liverpool University mural 58, 63, 73; fig.50
Long Sea Surf 9; fig.2
Lost Mine 56; fig.46
Lulworth 47, 49; fig.40

M

Marc, Franz 19
Martin, J.L. 16
Mellis, Margaret 16
Melville, Robert 7, 67
Minton, John 25
Mitchell, Denis 44
Moor Cliff, Kynance 43–4
Moore, Henry 22
 Internal and External Forms 22; fig.18
Morris, Guido 29, 30
Motherwell, Robert 46, 50
Mullion Bay 43–4, 69; fig.37
murals 6, 20, 58–9, 72, 73; figs.50, 51, 52

N

Newlyn Society of Artists 34
New York 46, 49–50, 68, 69–70
Nicholson, Ben 16–18, 19, 34, 37
North 32

O

Offshore 42, 50, 51–2, 57; fig.42
Orpheus 69

P

Palestine 19–20
Pasmore, Victor 15, 29
Penwith Gallery 44
Penwith Society of Arts 22, 32, 34
Penzance School of Art 14, 17
photography 21
Playtime 49; fig.41
Pollock, Jackson 46, 68
Pop Art 72
Porthleven 34, 36–8, 43, 58, 60; fig.29
Porthleven Boats 36–7, 39; fig.30
Portreath 32; fig.28
pottery 6, 73
Prelude 25, 26; fig.23
prints 6, 73

R

Rauschenberg, Robert 65
Read, Herbert 18–19, 34
 Annals of Innocence and Experience 18
Redgrave, William 44
Rome 21, 40, 42–3, 50
Rosenberg, Eugene 32
Rosewall 47
Rothko, Mark 46, 47
Royal Air Force 18, 19–21

S

St Ives 6, 11, 14, 16, 21, 29–30, 68, 70
St Ives Society of Artists 34
St John Browne, Sheila *see* Lanyon, Sheila
St Just 11, 38–40, 43, 68; fig.7
St Peter's Loft 44, 69
Salome 58
San Antonio Art Institute 60
Sarascinesco 50
Sarascinesco 40, 42; fig.33
Scott, William 43, 46, 49, 70
sculptures 6, 40, 42
Seeger, Stanley 50, 58
Seeger mural 58, 59, 63, 72
Self-Portrait fig.8
Silent Coast 47, 52, 69; fig.39
sketches 9
Smart, Borlase 14, 67
Smith, Richard 49
Soaring Flight 11, 52–3, 58; fig.43
Solo Flight 53
space in Lanyon's work 11
stained glass 6, 57–8
Stokes, Adrian 15, 16, 29, 46
 Colour and Form 14
supports 44–5
Susan 58
Sweeney, James Johnson 50
symbolism 39–40

T

teaching 37–8, 43, 44, 60, 65, 69, 70
technique 9–10, 36, 44–5, 46
Tel Aviv 19
Thompson, David 57
Tilson, Joe 65
'Time, Space and the Creative Arts' 36
Tinstone 29; fig.24
Treinen, Marie-Christine 43
Trevalgan 10–11; fig.5
Turn Around 56–7, 65; fig.48
Turner, J.M.W. 7, 67
 Rain, Steam and Speed 67
 The Shipwreck 7; fig.1

U

United States of America 7, 46, 49–50, 57, 58, 60, 62, 69–70, 72
Untitled 7; fig.9
Untitled (1939) fig.10
Untitled (Observatory) 62; fig.54
Untitled (Sunday) 42

V

viewpoints
 aerial 10, 46–7
 multiple 10–11, 40, 53

W

Wells, John 19, 29, 30
West of England College of Art 65
Western Desert 19–20
West Penwith 9; fig.4
West Penwith 31–2; fig.27
Wheal Owles 9; fig.3
White Track 17–18; fig.12
Wilson, Arthur 21
World War II 16–21
Wynter, Bryan 29, 30, 70

Y

Yellow Runner, The 22, 25, 26, 42; fig.17